GLENN BROWN

GLENN BROWN

Three Exhibitions

With texts by Rochelle Steiner, Michael Bracewell,
and David Freedberg

GAGOSIAN GALLERY

RIZZOLI NEW YORK

6–24 Britannia Street, London

15 OCTOBER – 26 NOVEMBER 2009

Window to Another World

Rochelle Steiner

He took his shirt off and wadded it in his hands. He was covered with Illustrations from the blue tattooed ring about his neck to his belt line.

'It keeps right on going', he said, guessing my thought. 'All of me is Illustrated. Look.' He opened his hand. On his palm was a rose, freshly cut, with drops of crystal water among the soft pink petals. I put my hand out to touch it, but it was only an Illustration.

. . . How can I explain about his Illustrations? If El Greco had painted miniatures in his prime, no bigger than your hand, infinitely detailed, with all his sulphurous colour, elongation, and anatomy, perhaps he might have used this man's body for his art. The colours burned in three dimensions. They were windows looking in upon fiery reality. Here, gathered on one wall, were all the finest scenes in the universe; the man was a walking treasure gallery. This wasn't the work of a cheap carnival tattoo man with three colours and whisky on his breath. This was the accomplishment of a living genius, vibrant, clear, and beautiful.

—RAY BRADBURY, *The Illustrated Man*, prologue, 1977

THE ILLUSTRATED MAN IN SCIENCE-FICTION writer Ray Bradbury's classic story is covered with fantastical images that come to life before the eyes of whomever he encounters, each picture telling a story and serving as a window to another world. Likewise, the figures in many of Glenn Brown's recent portraits—as well as the forms in his abstract paintings, science-fiction pictures, landscapes, and sculptures—are adorned with swirling marks resembling intricate tattoos. But with further examination, what appear as colourful patterns and surface textures emerge as embedded eyes, orifices, and suggestive features that point to alternate realities embedded within and underlying his subjects. A portrait, a figure, a head, or a foot might also be a ghost, a zombie, a planet, a faraway point. His swirling brushstrokes 'tickle the eye'[1] and entice viewers to look closer, leading to the discovery of unexpected, often haunting, otherworldly imagery lurking within the paintings' surfaces.

Over the course of his career, Brown has portrayed a cast of characters that are exquisite, flawed, and tragic, set in and displayed in relation to surreal and at times dreamlike surroundings. His fantastical imagery serves as a catalyst for viewers to consider secular notions of beauty, abject ugliness, youth, death, and decay, as well as conditions outside the realm of human existence. His 'creatures' are imbued with uncanny qualities, as if inhabited by ghosts and spirits that Brown encourages to seep into his work visually as well as conceptually.[2] Drawn from his wide-reaching knowledge of the history of art, a range of artists' works—from classically figurative to wildly abstract, extensively reproduced to obscure, and centuries old to recent—have functioned as muses for his art. At times the ghosts of those artists who came before him, as well as the ghosts of their subjects, infiltrate Brown's work, giving it a haunted quality.

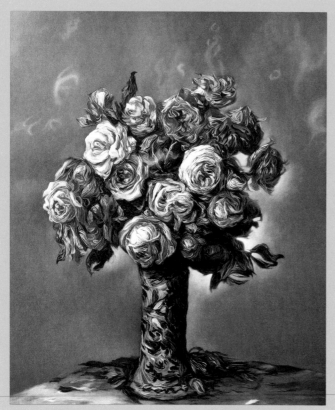

Fig. 1
Glenn Brown
Kill Yourself
2002
Oil on panel
82 × 68.5 cm
(32¼ × 27 inches)

With ideas in mind, he hunts for pictures in books to help him get there—seeking out 'bad' reproductions that are faded or poorly printed and reworking and embedding them into his creations, in whole or in part, alone or in combination.[3] Increasingly, he radically alters his muses in terms of shape, scale, orientation, cropping, and meaning with the use of inkjet printers, photocopiers, Photoshop, and various technical methods. Brown has likened himself to Dr. Frankenstein, creatively piecing together sections of figures, backgrounds, colour palettes, shadows, and compositions, among other elements—but his approach goes far beyond cutting and pasting to create works of art that are without doubt his own.[4]

One of Brown's recent figurative paintings, *Youth, Beautiful Youth* (2008, p. 57), depicts an old man suggestive of a Western vision of God in human form. With vacant eyes and a zombielike stare, he seems not entirely present or alive, but rather suspended between heaven and earth. He comes into view from the painting's green background like an ephemeral apparition, as if a gust of wind would cause him to dissipate and blend fluidly into the atmosphere. The image is composed of multi-coloured abstract marks that convey the look of modelled brushstrokes, and his hair and beard in particular are

composed of ribbons of colour that give the impression of dense, impasto layers of paint. However, the apparent depth and texture of these marks are belied by the artist's glassy smooth surface, typical of all of his paintings. Brown's visual source for this work was a reproduction of a Guido Reni painting, which he stretched and turned on its side so that the figure, dislodged from gravity, seems to float weightlessly across the picture's sky. The man is neither young nor beautiful, as the title suggests, instilling a peculiar ambiguity in the picture and a curious reconsideration of these human characteristics.

The virtue of youth as we know it is central to *Star Dust* (2009, p. 23), a portrait set against a gaseous and heavenly light-coloured background. Brown looked to an eighteenth-century painting by Jean-Honoré Fragonard to inspire the figure, and to Jeff Koons's sculpture *String of Puppies* (1988) for the dogs—traversing centuries and cultures to create a vision of humble innocence. The woman's sickly and yellowed face is accented by bold red and blue slashes of colour, resembling lips, eyebrows, and scars, and her blank stare through cloudy eyes gives the impression that she is in an impaired state. She displays a naïve enthusiasm for life and a pitiful attachment to the dead blue dogs.[5] Although her face and body are not as extensively tattooed with painted marks as many of Brown's figures are, a surprising insertion is tucked into her chin: a second set of lips, a third eye, or some inexplicable dark orifice, outlined in red. Similarly, the folds of cloth that envelop her—as well as the puppies

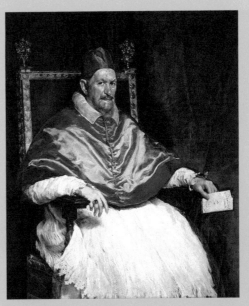

Fig. 2
Diego Velázquez
Portrait of Innocent X
1650
Oil on canvas
140 × 120 cm
(55¼ × 47¼ inches)

themselves—are covered with intense brushstrokes that create the mysterious visual fissures common in Brown's two- and three-dimensional works, prompting viewers to wonder what might lie within them.

In *Christina of Denmark* (2008, p. 59), Brown also considers youth and beauty, but from the perspective of loss and decay. This is one of a number of his images that depict a rocklike organic mass or perhaps an amputated limb that seems to be morphing through decomposition. Pink, fleshy tones on one side give way to dismal, lifeless yellow on the other; yet at the top and floating weightlessly are dashes of yellow that resemble thin sprouts of new growth, as if the odd form is also regenerating and supporting life. The image is covered in the artist's iconic swirls of colour, with many of the brushstrokes suggestive of entities prowling within the image's dark spaces, like maggots feeding on rot. Brown glorifies the strange and otherwise unidentifiable entity that serves as the painting's subject by presenting a 'portrait' of it in front of a monochromatic blue background. The artist did, in fact, draw upon a portrait of Christina of Denmark by Hans Holbein for this picture: in the sixteenth-century painting, commissioned by Henry VIII, she stands before a similar backdrop and likewise casts shadows behind her and to her side. Brown also looked to a painting by Georg Baselitz entitled *Eighth P.D. – The Hand* (*Achtes P.D. – Die Hand*, 1963), an abject image that infuses the spirit of Brown's painting but has been altered so significantly here as to be unrecognizable.

Brown approaches life and death with a morbid curiosity that permeates his work, from the skeletons in *Theatre* (2006) and *Suffer Well* (2007, p. 77), to the zombielike presence in *Seligsprechung* (2000), to the morose flower arrangement in *Kill Yourself* (2002, fig. 1). He increasingly invites viewers to consider alternate states of being and to glimpse what lies beyond our grasp. *After Life* (2009, p. 41), for example, alludes to the unknown through its title as well as its ambiguous visual form. A woman's torso, hip, and thigh area are twisted and contorted such that part of the body resembles a rootlike growth floating in space and seems to be in the process of transformation to a different organic form. The image occupies what Brown calls the 'no man's land between figuration and abstraction'.[6] He describes the figure's breasts as the eyes of a fantastical creature, a shift from human scale to another, either larger or smaller, depending on one's point of view.[7] Suspended between life and what comes next, this and all of Brown's imagery leads us to question not only what we are looking at, but also the human condition within the larger universe.

Many of Brown's images seem to materialise as if part of a dreamy meditation in which scale is disproportionate, gravity is upended, and reality is not as we know it. Under these conditions, ghosts and otherworldly figures appear, as in *Nausea* (2008, p. 63) and *The Great Queen Spider* (2009, p. 17). These related paintings reference Diego Velázquez's *Portrait of Innocent X* (1650, fig. 2), but also lurking is the spirit of Francis Bacon and his

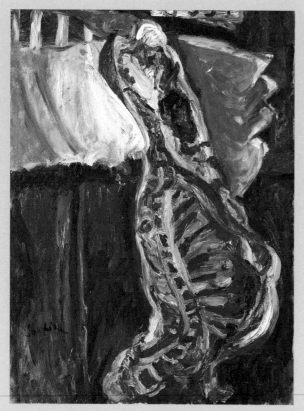

Fig.3
Chaïm Soutine
Side of Beef
c.1922–23
Oil on canvas
69.9 × 52.1 cm
(27½ × 20½ inches)

Study after Velázquez's Portrait of Pope Innocent X (1953).[8] In Brown's hands, the reproduction of the seventeenth-century image is irreverently turned on its head and distorted, as if the blood has been drained from the pope's body as part of his conversion into an ethereal winged creature. Devoid of flesh, the elongated bodies hang weightlessly, as if hovering between this world and another. The forms are tethered to the original paintings, particularly in *The Great Queen Spider*, in which Brown retains the letter held by Velázquez's pope; but by cropping the head and feet, he transforms the semitransparent entities into strange mothlike apparitions of undefined size, with a vertebrate structure at the bottom and decorative 'eyes' at the top.

Eerie and nebulous creatures likewise inhabit *Song to the Siren* and *Christ Returns to the Womb* (both 2009, pp. 35 and 29), both of which were inspired by Vincent van Gogh paintings distorted beyond recognition by Brown through inversion, cropping, and colouration. Here, for the first time, he has cut away the figures from their backgrounds, creating amorphously shaped rather than rectangular paintings, and has suspended them off the wall so they protrude into space. Hands and arms emerge monstrously from the sides of the pictures, and

Song to the Siren is inhabited by what appear to be the eyes of a mythical creature or an aberration lying in wait within Brown's brush marks. The more one tries to make out the subjects, the less clear these images become, in a visual interplay of the familiar and the unknown, resulting in an awkward uneasiness that is characteristic of Brown's work.

Increasingly at the forefront of his practice—particularly in this new body of work—is an exploration of the spirit world through enduring mythology and folklore. This is motivated, in part, by the artist's affiliation with the marshy region in the east of England where he grew up and local legends about an area taken from and returned to the sea. Brown recalls that, as a child, he constructed imaginary worlds, in his estimation more so than most youth.[9] Today, he continues to spend time in Norfolk, keeping a studio there, and is particularly attuned to this natural 'water world'. His work is infused with stories of such phenomena as the 'will-o'-the-wisp'—lights that form over bogs and swampy areas when gases build up and ignite—and the fabled Green Man, a creature thought to be part-human and part-nature that roams the British woodlands.[10] *The Organ-Grinder* (2009, pp. 18–19), a three-dimensional object inspired by a Walter Richard Sickert painting of figures coming out of the sea, draws upon such mythology. Light pink, pale blue, and lime green on one side, deep red and green on the other, Brown's sculpture is purposefully shapeless, and it is unclear whether it 'looks' upward

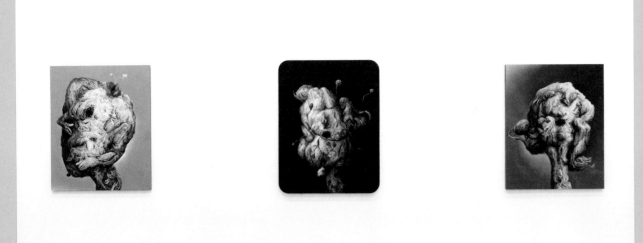

Fig. 4
Glenn Brown
retrospective at
Fondazione Sandretto
Re Rebaudengo, Turin,
28 May – 4 October 2009

or downward. *Debaser* (2009, p. 49) and earlier paintings such as *Deep Throat* and *Polichinelle* (both 2007, pp. 87 and 99) visualise the Green Man as an anthropomorphic 'head' covered in an array of leaves, blooming flowers, vines, and sprouts.

Orb shapes suggestive of heads have been prevalent throughout Brown's career, in both paintings and sculptures, and this is particularly true of a number of images inspired by Frank Auerbach's various renditions of *Head of JYM*. Brown draws parallels between Auerbach's exploration of Golem, a presence that might be illusory or monstrous, benign or haunted, and his own interest in the spirit world. He is also interested in Willem de Kooning's fusion of figuration and landscape, whereby human forms disappear into representations of nature in his paintings and his sculptures often resemble tree roots; connections can be drawn to Brown's morphing, organic imagery.

While Brown personifies heavenly phenomena and mythical creatures, he also creates images that resemble planets and has situated them within depictions of the macrocosmic depths of the universe. For example, in *Come All Ye Rolling Minstrels* (2009, p. 37), an obscure headlike form suggestive of a rocky planet floats against a vivid blue background evocative of outer space. It hovers within the painting's undefined surroundings unanchored by a horizon line or ground, making its scale and role in the cosmos unclear. This central element, drawn from Chaïm Soutine's *Side of Beef* (*Pièce de boeuf*, c. 1922–23, fig. 3) and the palette of an Ernst Ludwig Kirchner

painting, also resembles an animal carcass with a bony outer structure. While the entity itself appears to be in a state of decomposition, the painting gives the impression that it is supporting the eyes and features that cover its craggy surface as well as the red flowers that emerge jubilantly from the top. In this way, *Come All Ye Rolling Minstrels* is not unlike *Christina of Denmark* and previous works, such as *The Hinterland* (2006), *International Velvet* (2004), and *Seventeen Seconds* (2005) (from left, fig. 4), that feature the tension between decay and growth, as well as an uncertainty of form and scale. These unstructured blobs are colonised by intricate marks that resemble eyes, mouths, fingers, hands, tentacles, and other bodily and organic elements, and each image could be either human or alien, large or minute.

Brown's sculptures, which are far fewer in number than his paintings but are nonetheless central to his practice, similarly conjure up associations between heads and planets, meteors, and orbs from outer space. Among his large three-dimensional objects is *Wooden Heart* (2008, pp. 45–46), which resembles a scaled-up skull with depressed eyes and an elongated nose protruding from one side, not unlike the growths that shoot out from some of Brown's recent two-dimensional images. Yet *Wooden Heart* also appears to have been dislodged, like a meteoroid, from the imaginary world Brown depicts in his paintings and transported into the physical space inhabited by viewers. Covered in thick brushstrokes that stand vertically in defiance of gravity, the sculptures make

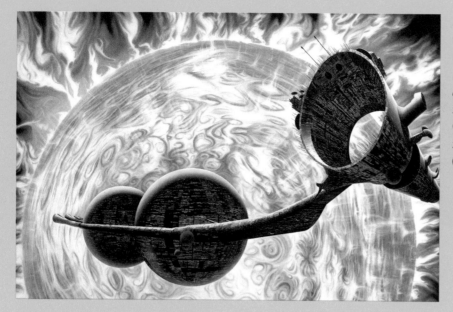

Fig. 5
Glenn Brown
*The Loves of Shepherds
(after 'Doublestar'
by Tony Roberts)*
2000
Oil on canvas
219.5 × 336 cm
(86½ × 132¼ inches)

tangible the marks that are otherwise illusory in his flat paintings. If the artist considers his paintings to be windows into alternate realities that lie beyond the gallery walls,[11] then his sculptures are artefacts from those other worlds brought into ours.

Fantastical images of outer space have been the setting for many of Brown's paintings, including *Böcklin's Tomb (Copied from 'Floating Cities' 1981 by Chris Foss)* (1998) and *The Loves of Shepherds (after 'Doublestar' by Tony Roberts)* (2000, fig. 5). The 'heads' in *The Angel of Monz* (2003) and *The Asylums of Mars* (2006, fig. 6) are suggestive of colonies in space: worlds within worlds are depicted, with detailed microimagery on surfaces of undefined size yet nonetheless endowed with macroscopic qualities. In these works, Brown confounds the viewer's perspective by commingling figurative details and seemingly universal surroundings, calling into question the possibility of other life forms and creating a moment of pause to consider something so unknown. Similarly, the more recent *Burlesque* (2008, pp. 51–52) merges science-fiction and still-life imagery to create an otherworldly setting teeming with alien forms. A group of apples inspired by a Gustave Courbet still life is rendered with Brown's signature brush marks, which populate the painting with what appear to be eyes, serpentlike tongues, and other features suggestive of life. At the same time, taken as a group, the apples merge to suggest a surreal vision of a reclining figure onto which a ray of 'religious' light is cast from above.

Part of Brown's speculations about space and depictions of alien possibilities is the location of familiar imagery within the context of the great expansiveness of the universe. In *War in Peace* (2009, p. 43)—as in the earlier *It's a Curse, It's a Burden* (2001) and *The Osmond Family* (2003, p. 131)—a giant human foot floats against an expansive background.[12] Set within a blue background suggestive of deep space, the vivid blue appendage is surrounded by tiny white marks indicative of faraway stars and is bathed in bright light that seems to emanate from them. Inspired by Adolph Menzel's *Artist's Foot* (1876), haunted by various paintings of a foot by Georg Baselitz from the 1960s, and infused with the colour of Picasso's blue period, Brown's otherwise debased form is elevated enough to be worthy of a 'portrait'. The glorification and reverence he extends to the humble foot highlights the religious undertone of his subject matter, which is reinforced by the red marks resembling stigmata toward its centre. However, decontextualised from the rest of the body and alone in the atmosphere, the foot is also a self-contained world. Covered in Brown's characteristic curly brushstrokes and intricate patterns reminiscent of the detailed tattoos that embellish Bradbury's Illustrated Man, it is home to small eyes, mouths, and features that suggest creatures lurking within the abject image's dark and cloudy crevices.

Throughout his career, Brown has created works that offer viewers opportunities to reflect on microscopic and macroscopic aspects of the human condition, as well

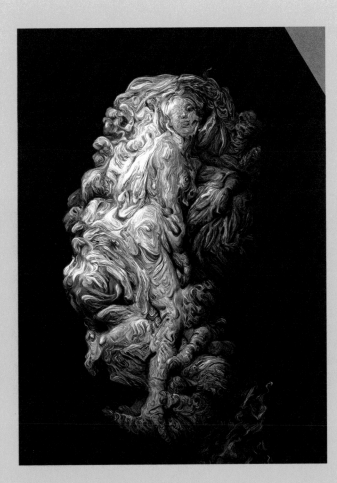

Fig. 6
Glenn Brown
The Asylums of Mars
2006
Oil on panel
156 × 122.5 cm
(61⅔ × 48¼ inches)

as alternate realities that may be bigger or smaller than
our own, tangible or intangible, imaginable or fantastical.
In doing so, he creates a platform for us to see ourselves
as part of and in relation to the world at large. On one
hand, the planet is filled with unique individual beings,
like the figures that appear in his portraits: each is a world
unto him- or herself, covered by minute marks and life
forms that both comprise and are supported by human
existence. On the other hand, we are but small parts
of an expansive universe that may also be inhabited by
the spirits and life forms suggested by his imagery. By
commingling known and unknown elements, and by
calling to mind religion, mythology, science fiction, and
other windows onto the world, Brown not only invites
us to consider where we stand in the universe, but also
encourages unsettling and provocative glimpses into
what lies beyond.

1 This description of the effect of Brown's painting technique is from the artist's father and was relayed to the author by the artist in an interview in London on 30 May 2009.

2 Regarding the ghosts in his work, see my interview with the artist in *Glenn Brown* (London: Serpentine Gallery, 2004), pp. 98–99. See also his interview with Douglas Fogle in *Brilliant! New Art from London* (Minneapolis: Walker Art Center, 1995), p. 16.

3 Brown's first art book was *Images of Horror and Fantasy* by Gert Schiff (London: Academy Editions, 1980). A gift from his brother in the mid-1980s, it sparked his intrigue, with its images of decomposing bodies and the grotesque in art, and continues to serve as a reference. While there has been considerable interest in identifying the artist's source images, according to Brown they are somewhat arbitrary. He has commented that his work is about ideas, not images, and that source images serve as vehicles for ideas rather than subjects for his paintings. Interview, London, 30 May 2009; see also the interview with the artist by Michael Bracewell, 5 May 2009, Tate Liverpool (www.tate.org.uk).

4 Brown discusses his Frankenstein approach in my interview with him in *Glenn Brown*, p. 96. It is worth noting that he suffered from claims of copyright infringement early in his career; this is discussed in the same interview, p. 97.

5 Interview, London, 30 May 2009.

6 Interview with the artist by Katarzyna Uszynska, in *Glenn Brown* (Vienna: Kunsthistorisches Museum, 2008), p. 34.

7 Interview, London, 30 May 2009.

8 According to Brown, the Velázquez image was the muse for the painting and he deliberately tried to avoid making reference to the Bacon painting, which is well known and widely reproduced in the United Kingdom. However, he credits the Bacon image with 'setting up the challenge' for his painting. (Conversation with the artist, 21 August 2009.)
Given Brown's interest in appropriation, it hardly seems coincidental that he would select an image that had already been quoted, reworked, and reinterpreted by another painter, if only to move the resulting image further from the original source. He took a similar approach in *After Life*, where he looked to a Eugène Delacroix rendition of a Peter Paul Rubens landscape for inspiration.

9 Interview, London, 30 May 2009.

10 The will-o'-the-wisp has made frequent appearances in literature and popular culture, taking on a variety of forms, as depicted in such books and films as Charlotte Brontë's *Jane Eyre*, Bram Stoker's *Dracula*, J.R.R. Tolkien's *The Lord of the Rings*, and J. K. Rowling's *Harry Potter* series, among others.

11 Interview, London, 30 May 2009.

12 For a discussion of *The Osmond Family* and *It's a Curse, It's a Burden*, see Christoph Grunenberg, 'Capability Brown: Spectacles of Hyperrealism, The Panorama and Abject Horror in the Painting of Glenn Brown', in *Glenn Brown* (London: Tate, 2009), p. 23.

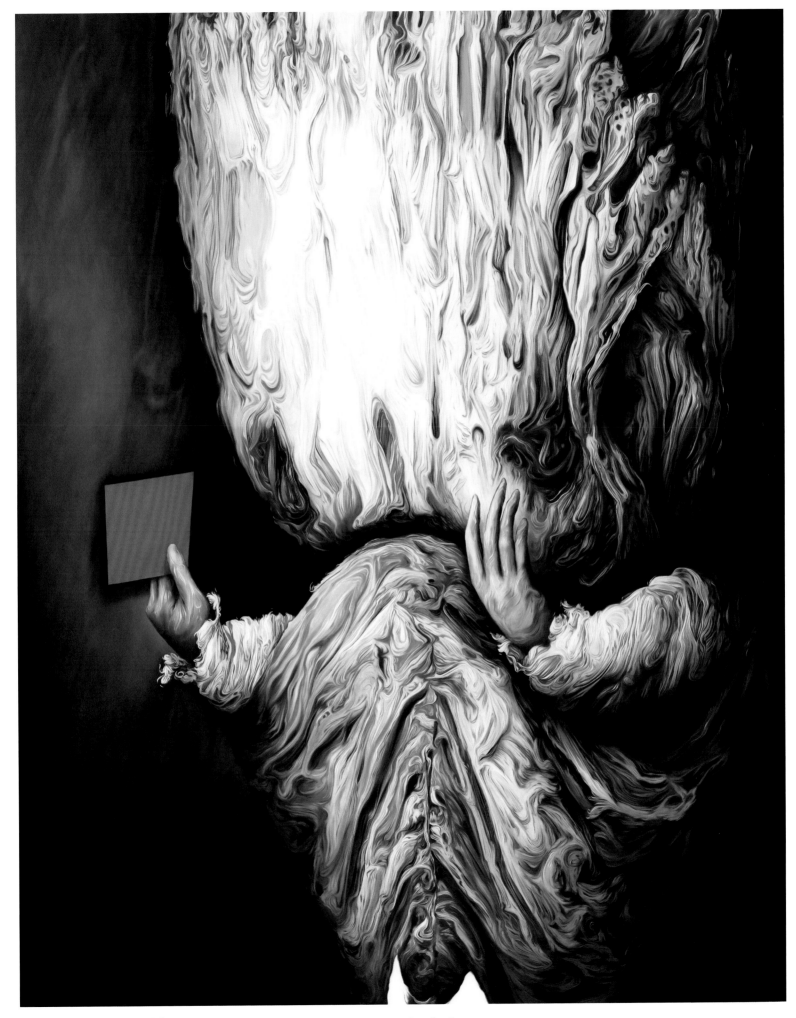

The Great Queen Spider 2009, oil on panel, 150 × 120 cm (59 × 47¼ inches)

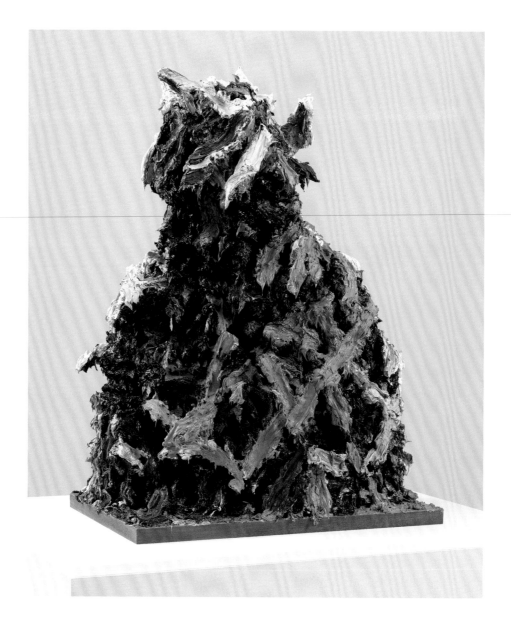

The Organ-Grinder 2009
Oil paint on acrylic medium on metal armature
97 × 77 × 58 cm
(38¼ × 30¼ × 22¾ inches)

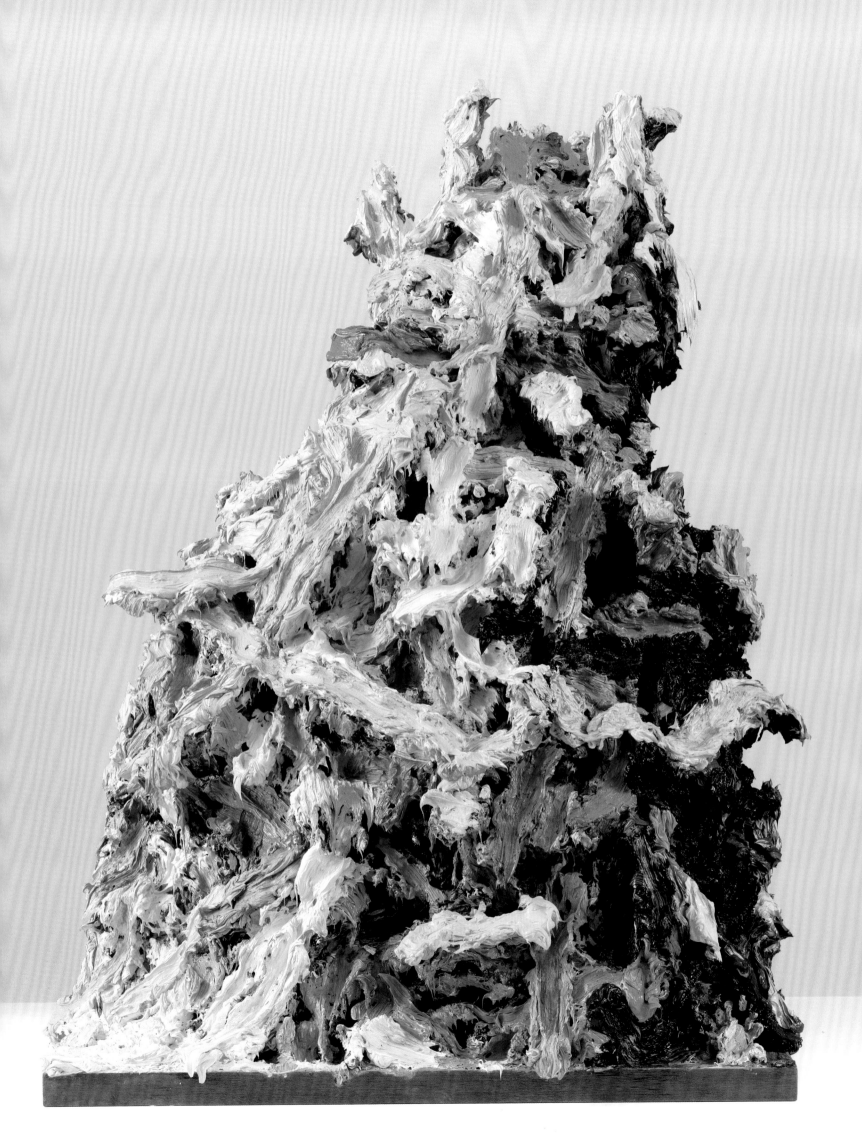

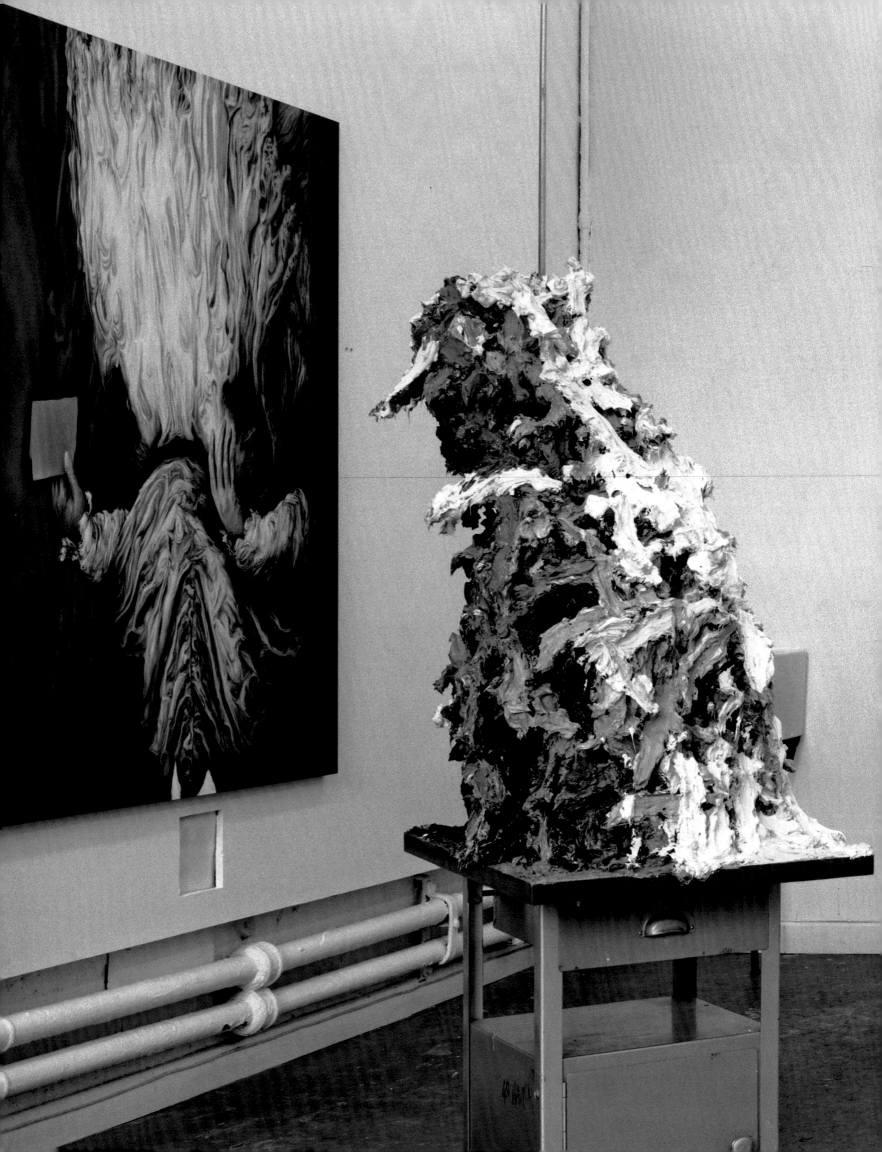

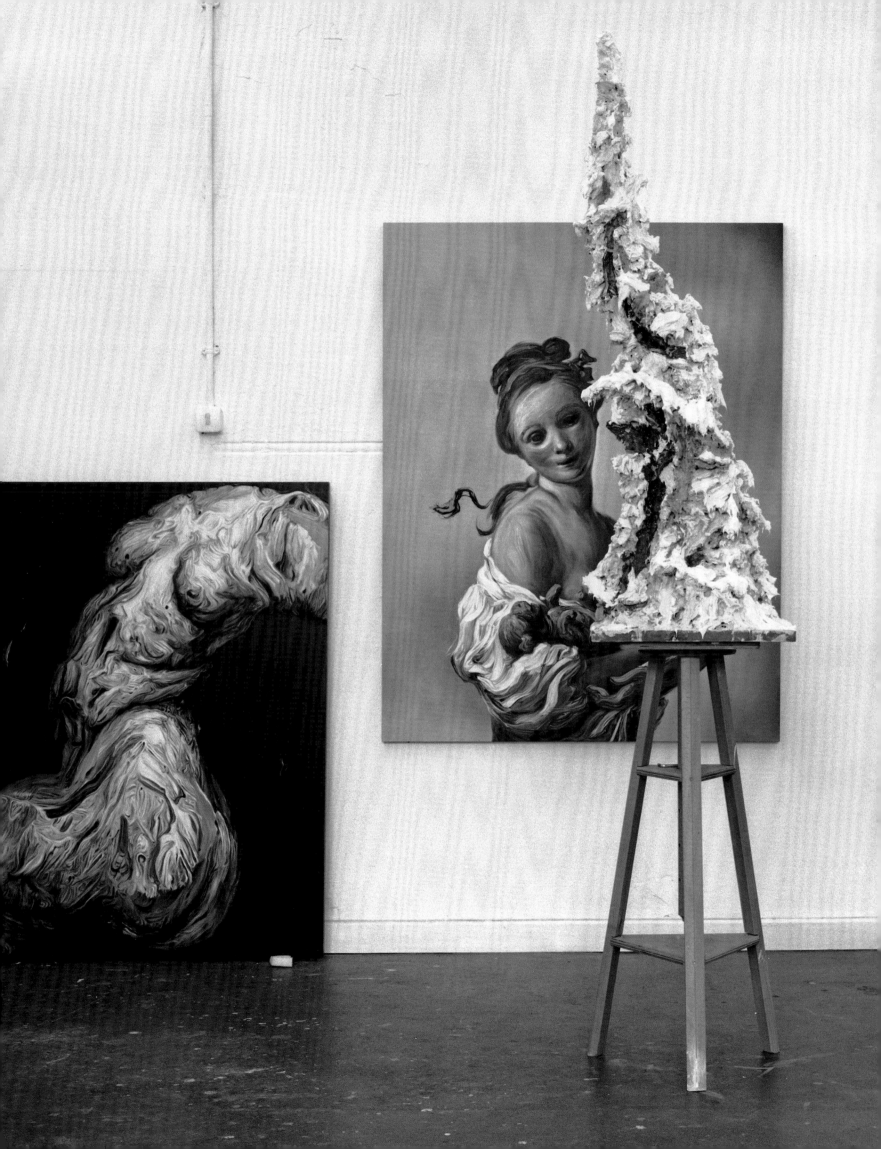

Star Dust 2009
Oil on panel
154 × 122 cm
(60¼ × 48 inches)

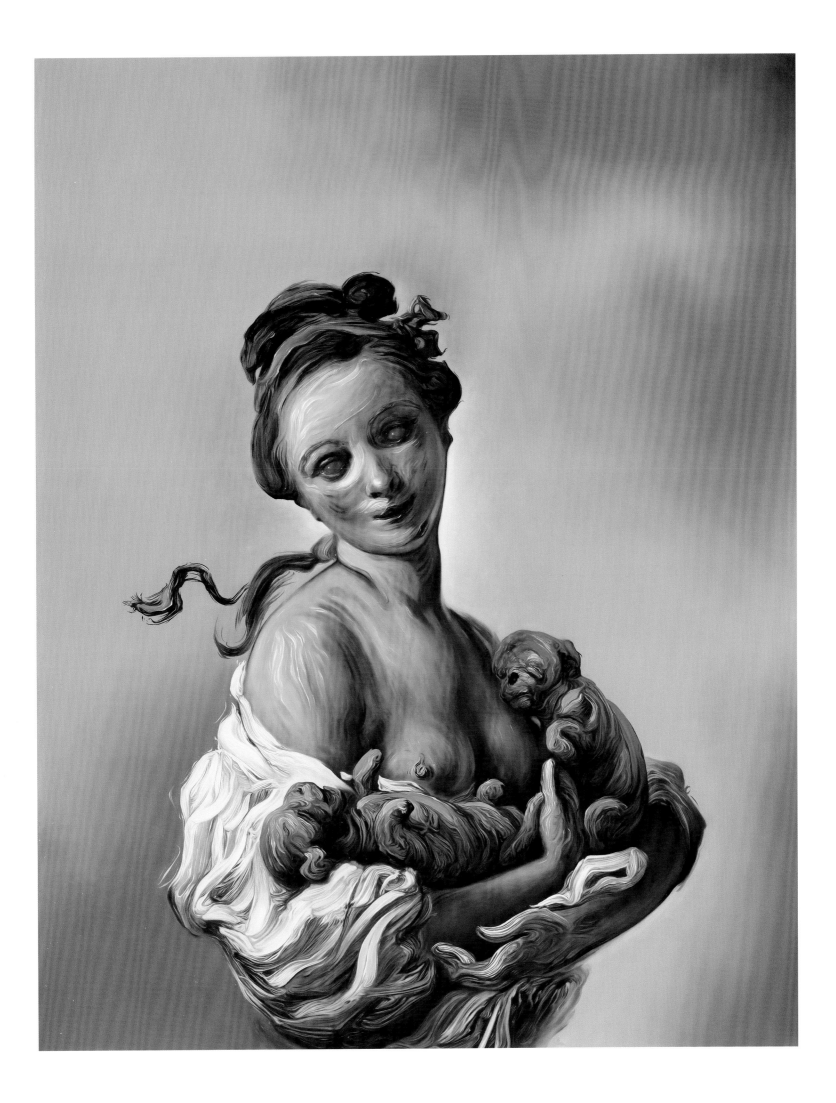

Spearmint Rhino 2009
Oil on panel
194 × 260.5 cm
(76½ × 102½ inches)

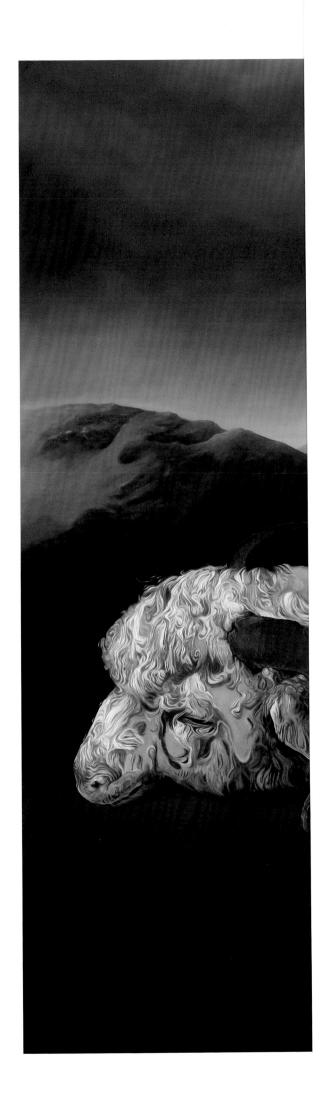

Christ Returns to the Womb 2009
Oil on shaped panel on steel support
269 × 152 × 18 cm
(106 × 59¾ × 7 inches)

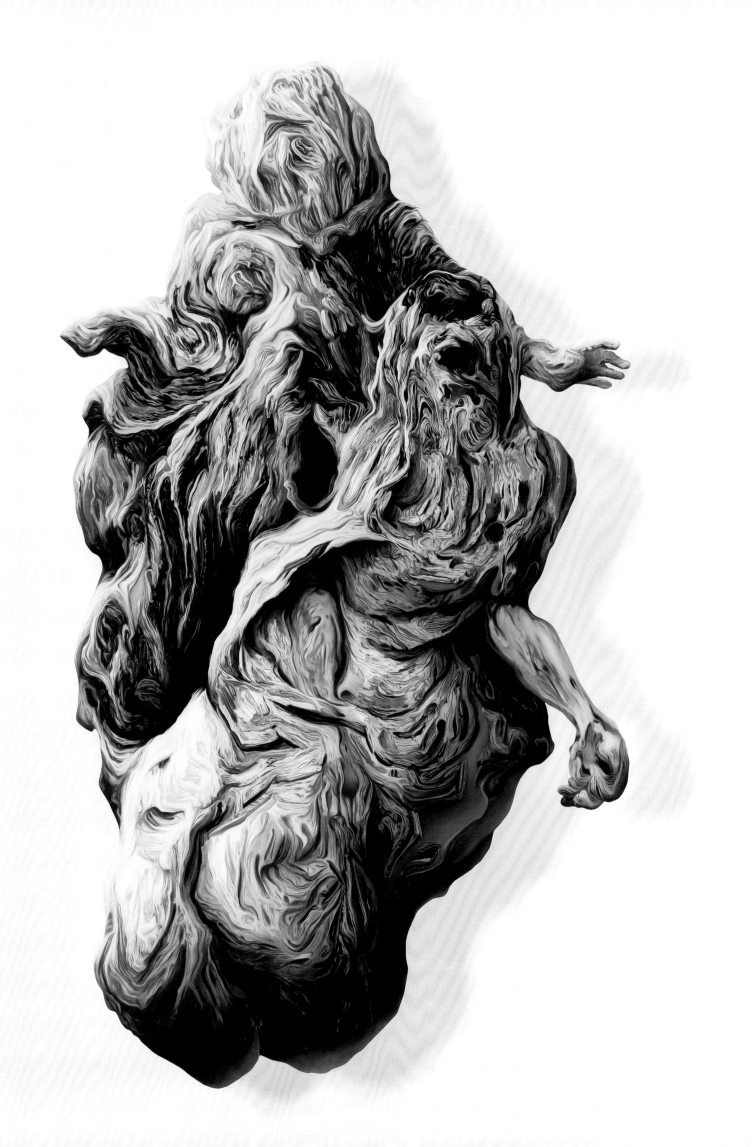

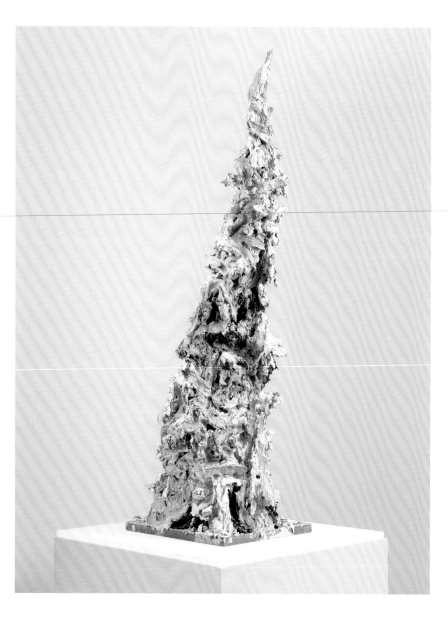

If you know how to get here, please come 2009
Oil paint on acrylic medium on metal armature
147 × 50 × 41 cm
(58 × 19¾ × 16¼ inches)

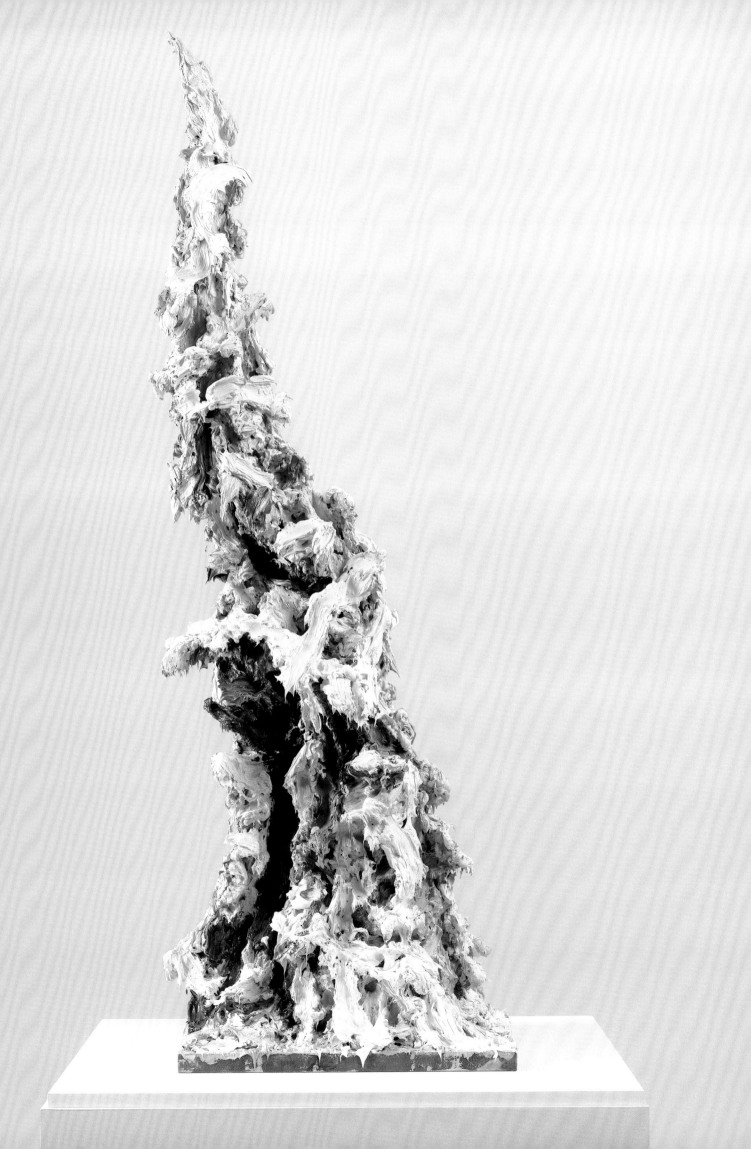

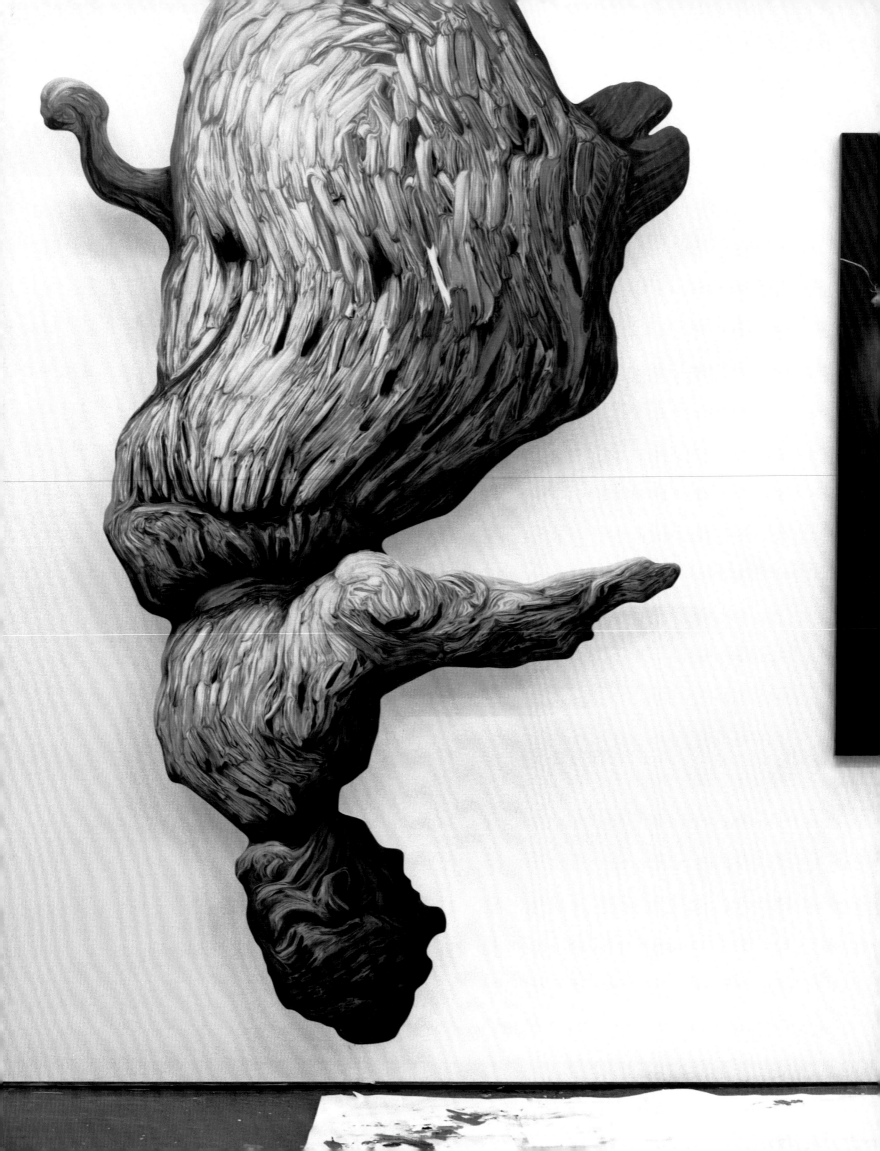

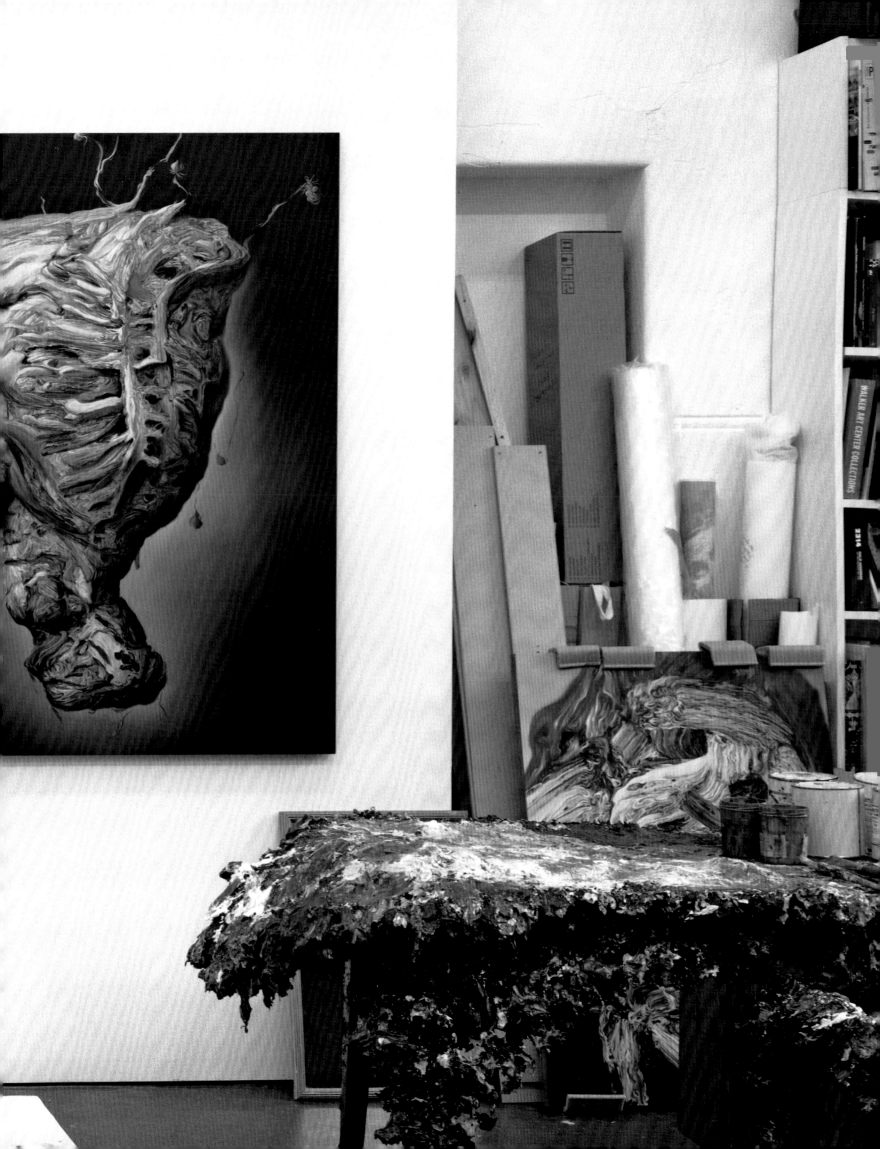

Song to the Siren 2009
Oil on shaped panel on steel support
250 × 148 × 18 cm
(98½ × 58¼ × 7 inches)

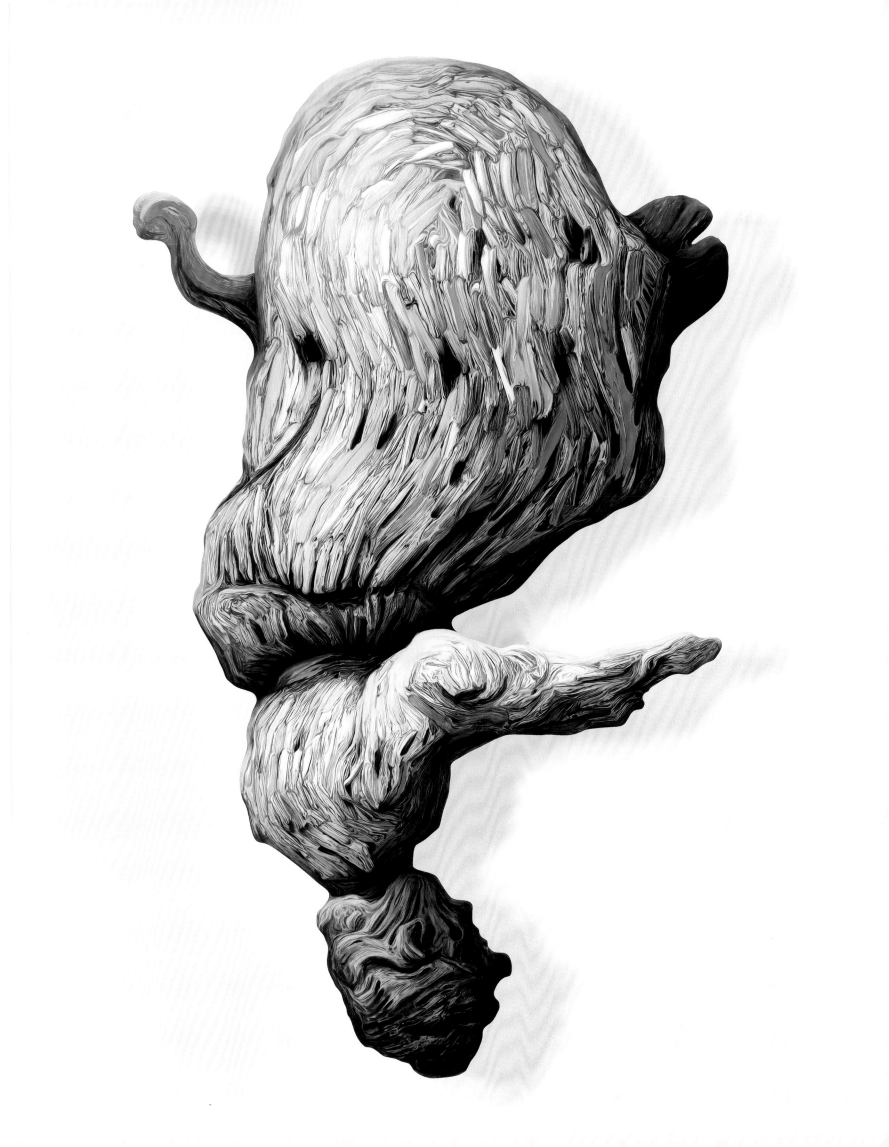

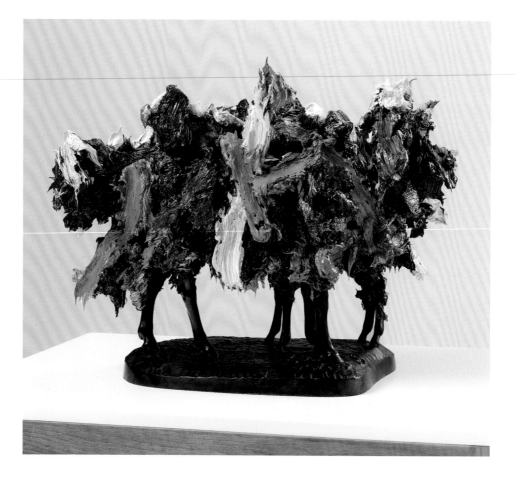

Monument to International Socialism 2009
Oil paint on acrylic medium on bronze
38 × 52 × 37 cm
(15 × 20½ × 14½ inches)

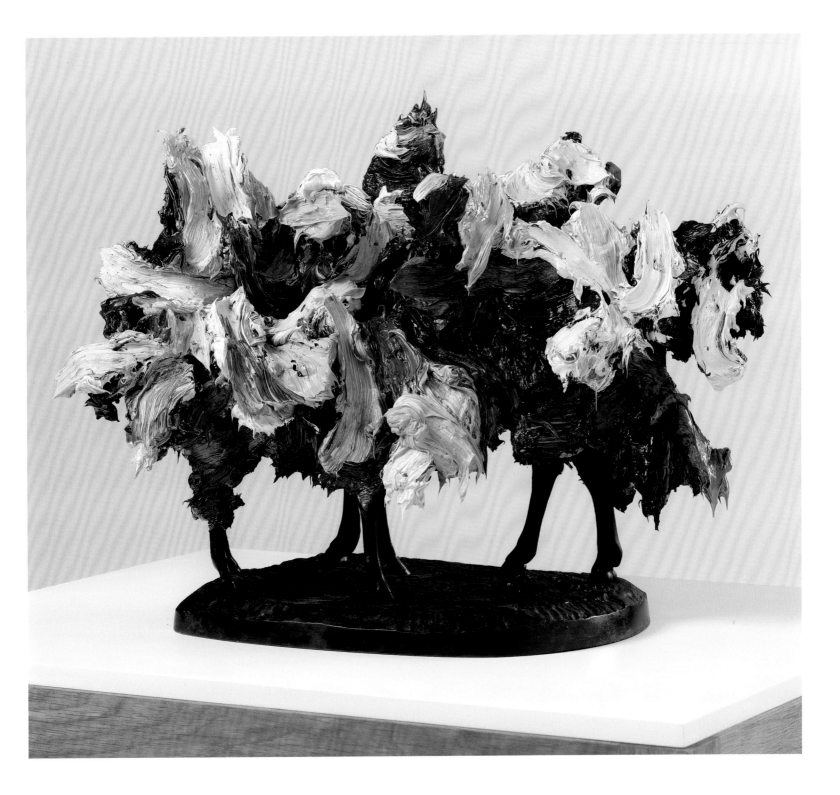

After Life 2009
Oil on panel
138 × 114 cm
(54¼ × 45 inches)

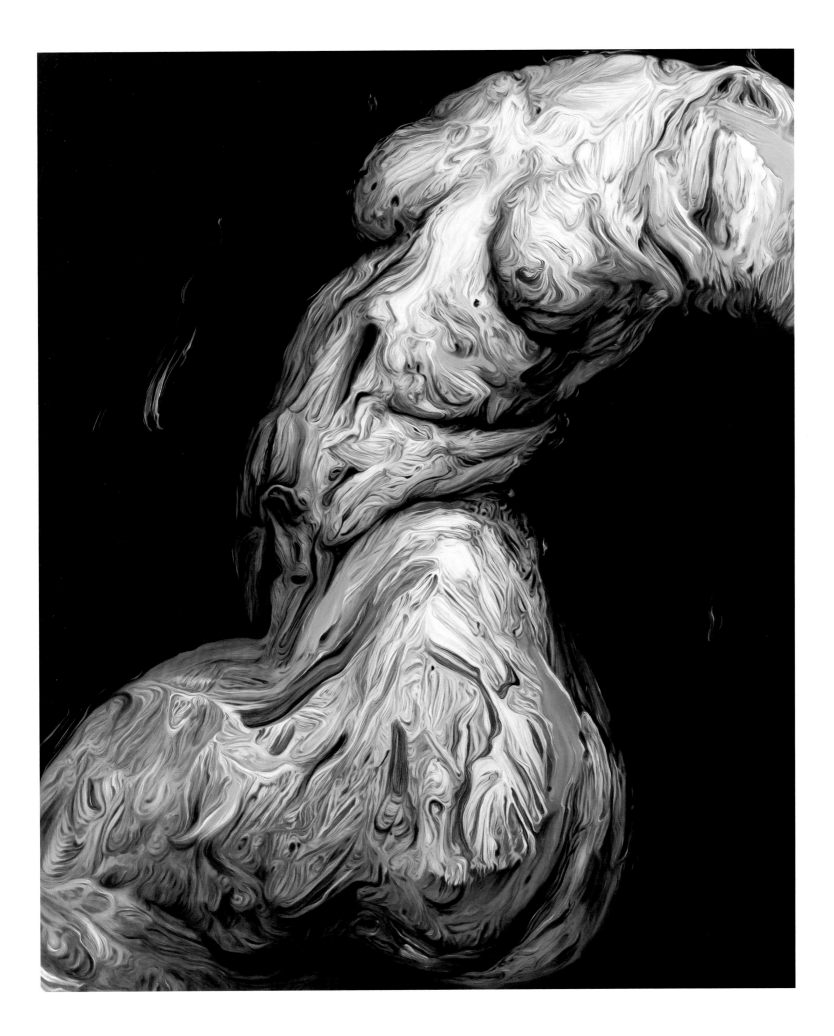

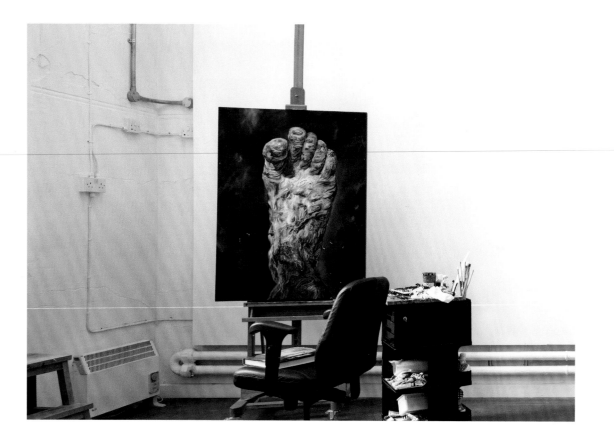

War in Peace 2009
Oil on panel
116 × 87 cm
(45¼ × 34¼ inches)

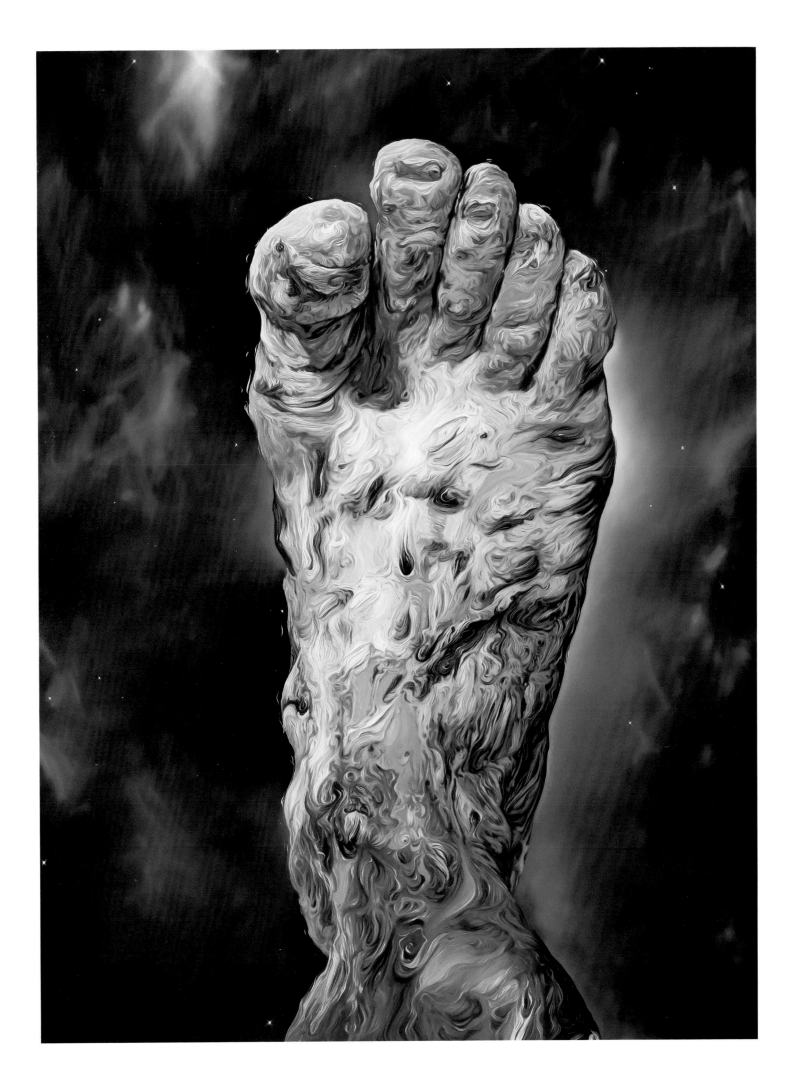

Wooden Heart 2008, oil paint on acrylic medium on metal

Burlesque 2008
Oil on panel
121 × 220 cm
(47¾ × 86½ inches)

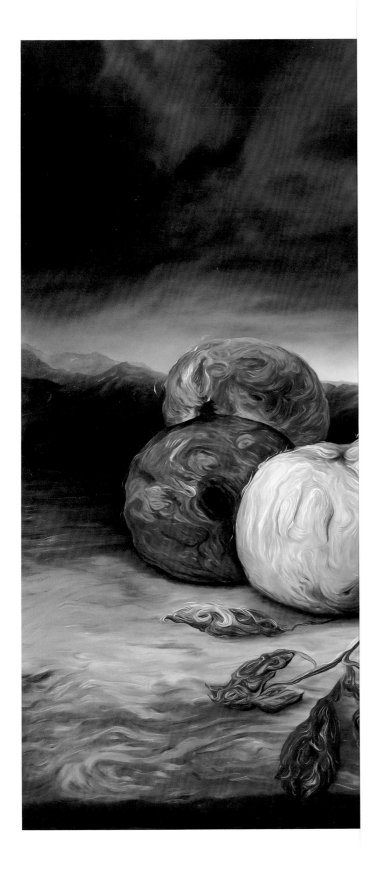

Soul Disco Ambient Funk 2009
Oil on panel
98 × 71.5 cm
(38½ × 28 inches)

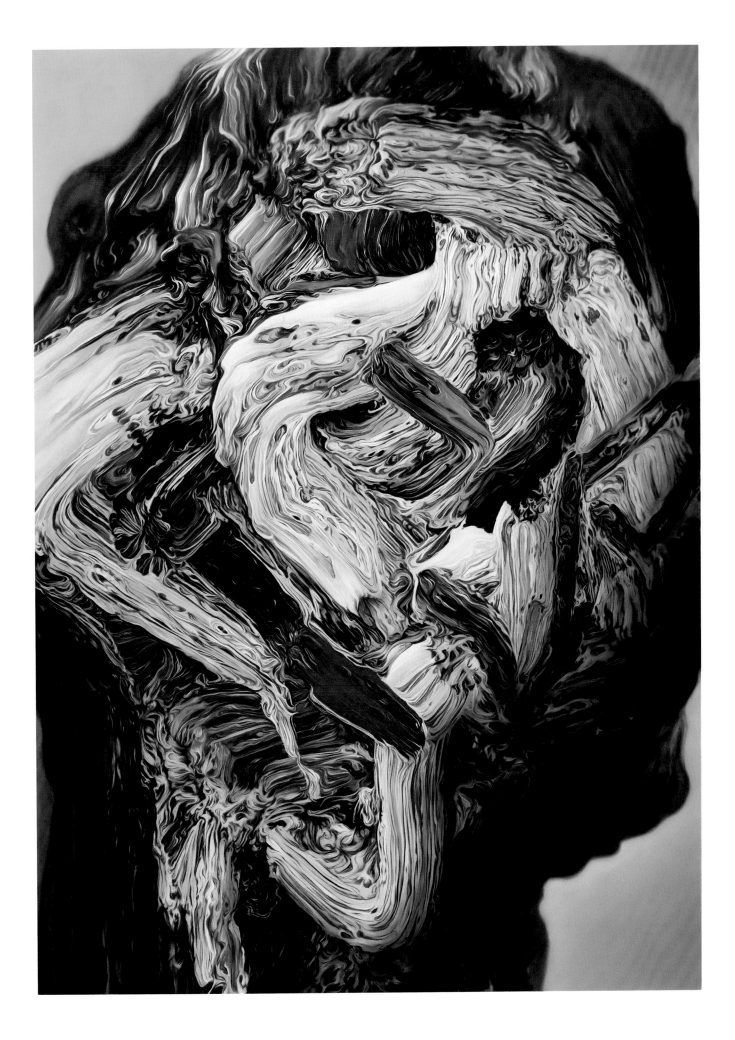

Youth, Beautiful Youth 2008
Oil on panel
153 × 121 cm
(60¼ × 47¾ inches)

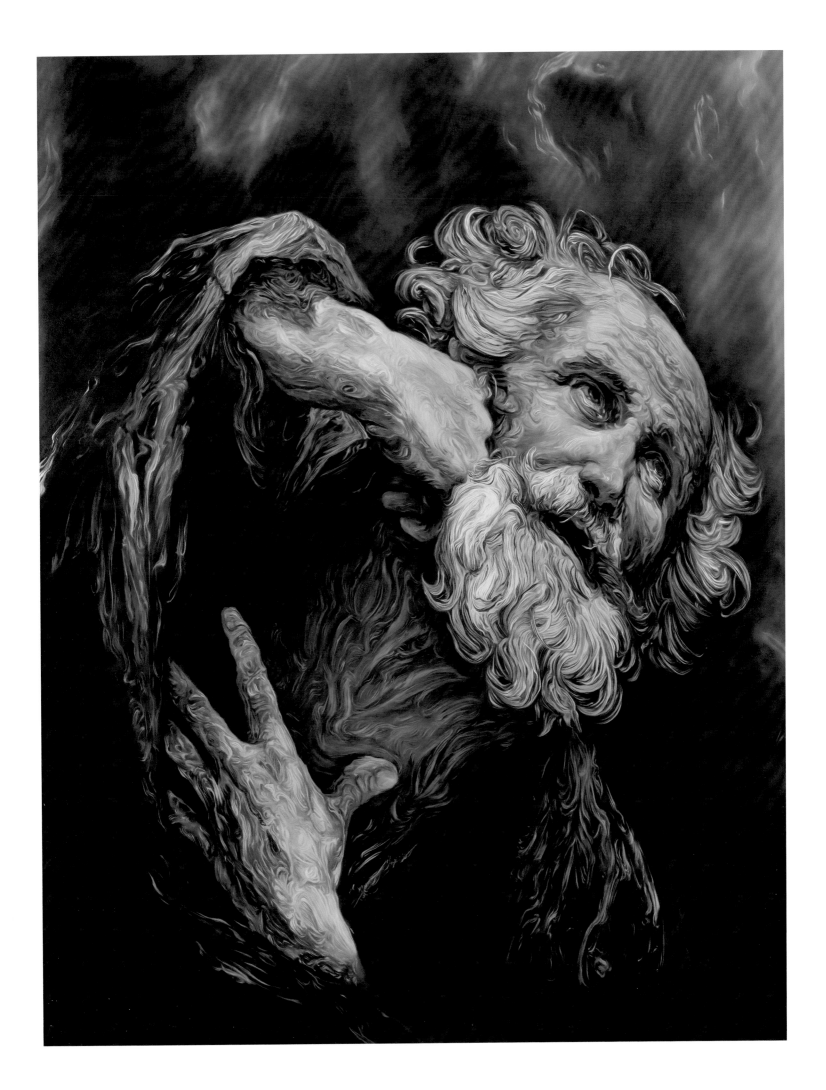

Christina of Denmark 2008
Oil on panel
165 × 119 cm
(65 × 47 inches)

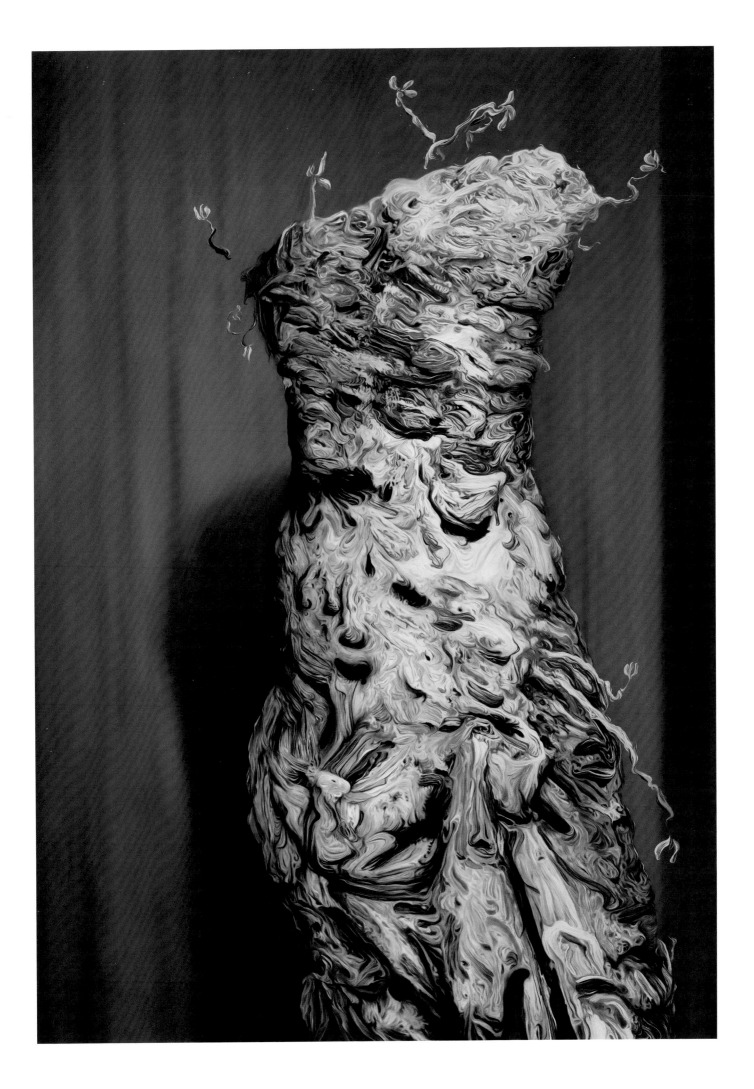

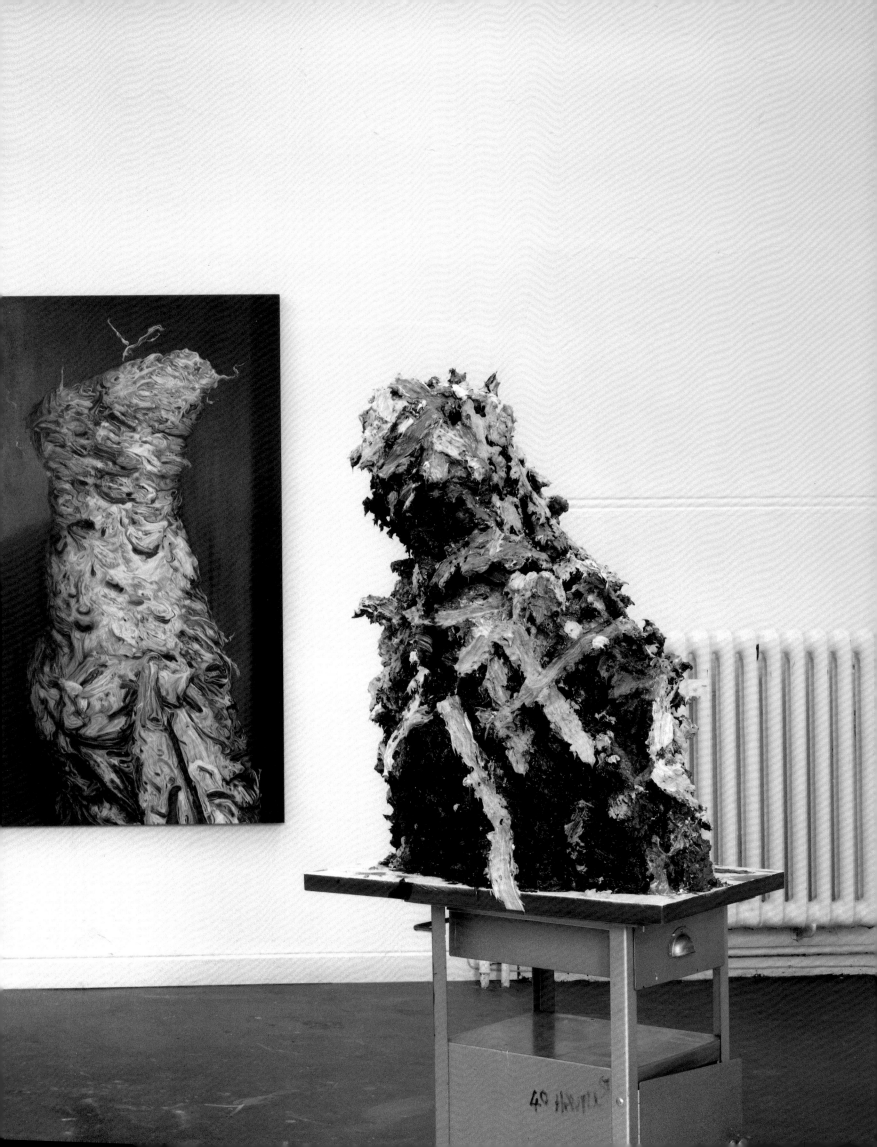

Nausea 2008
Oil on panel
155 × 120 cm
(61 × 47¼ inches)

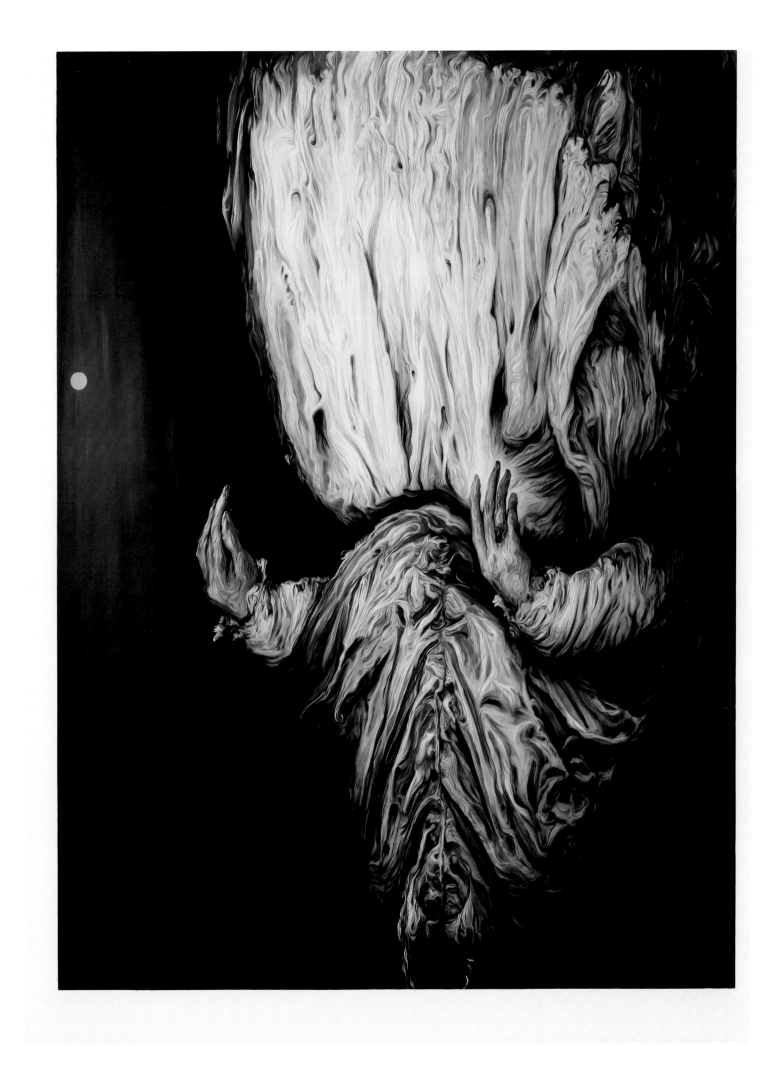

555 West 24th Street, New York

3 MAY – 9 JUNE 2007

Concerning the Art of Glenn Brown

Michael Bracewell

I tend to think of the exhibitions I do as a loose accumulation of paintings with no single theme—like a variety show. A comedy act, a magician, dancing girls, a ventriloquist, and of course a good impressionist make, I think, a reasonable show. In other words, no; this exhibition, as with all the shows I have had so far, has no title.
—GLENN BROWN

CAUGHT AS THOUGH AT THE MOMENT OF liquefaction, trailing, fragmentary, yet somehow filled with intent, the colours brood, thicken, and broil. High aesthetic strategy gives verse to trenchant morbidity, deliquescence, and rot. Palest pink and liquid violet abut satanic vermilion—an alarming confection. Curlicues of gauzy silver extrude in vaporous slipstream from the depths of haunted furrows; shades of fervid emerald putrescence appear bent to depictions of mannered splendour. In the art of Glenn Brown, nothing is quite as it seems, although all is as it appears. The occupants of his paintings are the stuff of dreams. Step forward, purple-haired, veiled-eyed, sallow-skinned young shepherd boy and coy scarlet lamb! In this, Brown's paintings are above all *performances*: séance as vaudeville; the clanking of chains as 'easy listening'.

'The studio was filled with the rich odour of roses, and when the light summer wind stirred amidst the trees of the garden, there came through the open door the heavy scent of lilac, or the more delicate perfume of the pink-flowering thorn.' So opens Oscar Wilde's novel *The Picture of Dorian Gray*. The scene set—artistic London, a fragrant day in early summer—, the reader is introduced to the artist Basil Hallward, who is being visited by the philosophising aesthete Lord Henry Wotton. They converse on the nature of art and artists, on the representation of beauty in art, and in particular on the beauty of youth. But we are in a world of incense and velvet. Lord Henry's heavy, opium-tainted cigarette, no less than the sullen murmur of bees that renders the stillness of the studio even more oppressive, pronounces the temper of fin-de-siècle decadence.

A time-travelling Glenn Brown, dispatched through various temporal dimensions from his own London studio to that of his fictitious late-Victorian brother-artist, might well be tempted to step forward and contribute a few remarks of his own. And were Hallward and Wotton to return his visit, joining him in twenty-first-century Shoreditch, they would find much in Brown's painting to stop them dead in their tracks. For Brown's art is drawn from some deep, hidden crease in aesthetic philosophy, a place where the constitutions of art and beauty and the capacities of painting are collapsed and reconfigured, possibly, primarily, for no other reason than his own entertainment. Lord Henry's delight in paradox—'I can believe anything, so long as it is quite incredible'—would be answered aperçu for aperçu by the seemingly effortless elegance with which the conceptualism of Brown's art is rendered so eloquent by the virtuosity of his technique.

In one sense, it might be seen as a Pop-hip descendant of Augustan Mock Heroism (the eighteenth-century fusion, in English poetry, of classicism and satire); sliding down the same sunbeam, so the flippant, aphoristic philosophising of Wilde's aesthetic avatar is a decadent evolution of the Augustan wit of John Dryden and Alexander Pope. The common denominator in this dizzying but noble lineage is a honed understanding of the relationship, artistically and metaphysically, between surface and depth. In experiencing Brown's art, it is as though we fall right through the pristine, utterly smooth surface of his beguiling paintings, into the extreme depths of a profound aesthetic statement—as surely as Jean Cocteau's fatefully inquisitive poet in his seminal film *The Blood of a Poet* (*Le sang d'un poète*, 1930) falls through the surface of a mirror into the parallel reality of a none-too-comforting afterlife. We find ourselves in a vertiginous underworld, a place beyond the looking glass, somewhere seemingly within the shadow of human psychology, but having one of its better days.

Whether the subject is a skull, a floating city, a reclining figure, a beauteous youth holding a lamb, dead birds, a fleshy maiden, or some unknowable, anthropomorphic being, Brown's paintings are all, in a way, psychological portraits. They describe accumulated thought as pictorial mulch, as though the pulses and currents of the mind could be seen as corporeal matter. The Freudian silage of lumpen subconsciousness is not merely given shape, colour, and form by the artist, but brought to life to parade around in the raiments of elevated, enshrined, iconic beauty. Brown delights in the capture of those works by other artists that he feels might be colonised by his own concerns; the most senior constellations in the firmament of art history, more often than not, comprise his targets: Auerbach, van Gogh, Fragonard, de Kooning, John Martin. There is a slapstick element in this process, the conceptual equivalent of a person clubbed from behind with a sock filled with wet sand, a sack thrown over his head. The only limits to Brown's audacity are those imposed by his impeccable taste. However, the exuberance and verve of his painting, for all its gothic underpinnings, is derived from its resolution of contradictions. Thus, simultaneous to his aesthetic connoisseurship, he is less concerned with the art-historical status of those works he appropriates than with their ability to serve his purpose—namely, his epic exploration of paint and painting.

Just as Basil Hallward's portrait of Dorian Gray, through some perverted act of transubstantiation, reveals the decay and corrupting soul of the sitter while Dorian himself remains eternally ageless and handsome, so in Brown's art we see a fateful contract between painting itself, the history of art, and the processes of aesthetic putrefaction. In this, I am reminded, strangely, of John Milton's masque *Comus*, in which an evil sorcerer attempts to persuade a chaste and hapless virgin, lost in dark and tangled woods, that if we do not live for pleasure in a state of perpetual, orgiastic consumption,

then Nature herself will be 'strangl'd with her waste fertility'. Such an argument might neatly double as an allegory of the postmodern condition: an unstoppable glut of visual culture, faced with either starvation or bulimia, becomes gorged on a surfeit of sheer stylistic gorgeousness. Further parallel might be found in the actual performance of *Comus*. To borrow from Isabel Gamble MacCaffrey's illuminating *Introduction to Milton's Shorter Poems*, 'It is the form that permits such ambidextrous vision: the personages of allegory, neither "realistic" nor "symbolic", but both at once, move simultaneously in concentric worlds', as do the 'subjects' of Brown's paintings, dually operational between their lives as source material and their afterlives as replicas or mutants. We find, for example, amongst these most recent paintings, a triumphal female figure: given her commanding pose, she might have been looted from an allegorical frieze or kidnapped from some assuredly aristocratic mise-en-scène. Brown, an accomplished grave-robber, has found a subject who summons with a backward glance, serene, aloof, her mouth a sensuous gash, a lock of her extravagant coif making a soft curl above the nape of her neck. Her décolletage, however, exposes mint-blue skin; the flounces and billows of her dress have a pallid, rusty, oysterish hue, their folds extrapolating into nameless weals and folds of unctuous colour, supreme above the bulbous mounds of what appear to be three rouge-nippled, milky breasts and the collapsed length of a fiery-tipped, monstrous phallus. The background is bible-black, with a gaseous circle of silvery luminescence against which the central figure, our joyous and imperious lady, rides a riot of colour and form.

On first acquaintance, it is the visual luxuriance of Brown's painting that draws the viewer deeper and deeper into the heady gravitational field with which each work appears to be surrounded. And this has been a constant throughout his work. One may encounter a flotilla of asteroids, colonised by clusters of squat illuminated towers, some of which are topped with vast spheres (*Böcklin's Tomb [Copied from 'Floating Cities' 1981 by Chris Foss]*, 1998). The surrounds of deep space are submarine, ink-blue, fathomless. Look closer at the craggy bulk of the nearest floating city and study the protruding, moonlit rims of what could be the outlets of the asteroid's internal engines: they emerge from cliffs of cold, shadowy rock, and, this being the world of science fiction, their dark mouths might be thousands of miles wide or so small as to be almost invisible to the human eye. Above all, the painting is visceral in its articulation of weight and weightlessness. In turn, the viewer, drawn toward the painting's surface, feels to have entered the magnetic field of Brown's dizzying aesthetic, an endlessly tensile place, the physics of which are derived from simultaneously active currents of repulsion and attraction. The surfaces of the paintings, as smooth and flat as a matte photograph, often create the illusion of being dense, heavily worked layers and encrustations of paint. One approaches the paintings in anticipation of a virtually

tactile experience, to be met instead by cool flatness. This chill, however, is as distant from cold intellectualism as it is from signifying the merely pristine. The deceptively smooth surfaces serve to further heighten the paintings' undeniable sentience; one feels to be in the presence of some near-chemical process resulting from Brown's bravura fusion of intention, selection, interpretation, and vision. Vampiric, he drains his chosen subjects of their original life fluids; rendered lifeless, malleable, they then become open to reanimation.

I always like to think of my paintings as double-edged, being between ugly and pleasurable. One reaction I get from people is that they don't like looking at them, that they repel the eye. I think this stems from something about their flatness, and the almost irksome sense of detail in them. Also from the fact that you don't quite know what you're looking at: you see brush marks, but they're not 'real' brush marks—they're fake in one sense.

For a long time I was criticised on the grounds of 'one day he'll get around to doing his own thing', as though, eventually, I would grow up and stop copying other people's pictures. This pressure came from other artists as well. This criticism happened less in America, where Pop art had changed attitudes to art; but in England the idea of appro-

priation is still not quite accepted. It's rather as though, because the whole thing isn't seen as having poured out of my own soul, I'm not really a proper painter. But I have determined that appropriation is fundamental to what I do, and so all my work has a basis in other works of 'high' or 'low' art.

I like my paintings to have one foot in the grave, as it were, and to be not quite of this world. I would like them to exist in a dream world, which I think of as being the place that they occupy, a world that is made up of the accumulation of images that we have stored in our subconscious, and that coagulate and mutate when we sleep. There is a certain point, for me, in the process of making a painting when the painting itself starts telling me what to do. Subsequent to the earliest stages of building the initial layers of colour and form, I reach a point where I no longer have to force my will on to it. I realise that the painting has reached a stage where it has its own personality.

I liked the idea of painting a decrepit or melancholic skull that could also have the sensibility of dance music. I think that in painting or music you do look for those sudden changes of emotion; and it is when such changes creep up on you that they seem to have the most effect. Whether it's Degas, with his bizarre use of colour—very heightened colours depicting quite banal subjects—or de Kooning, with a colossal sense of aggression in the brush marks, yet a palette of pink and yellow ice-cream colours.

There is a struggle in my work between figuration and abstraction; and I always want to make abstract paintings. I like that idea of having a painting as straightforwardly raw as possible, without figuration getting in the way; so it's just about colour and drawing and form. One of the reasons I liked making the science-fiction paintings was that there was something very abstract about them. I think science fiction is an abstract space where anything can happen, really. It's a blank canvas on which to invent what you like; and there's no gravity, which is a thing that abstract painting generally tried to achieve—you could turn the painting any way up and it would still work.

The paintings in Tony Hancock's film The Rebel *(1961) look very engaging. They were made ironically, but thirty years after the film was made, that irony would be considered tasteful, to be great 'bad taste'. The sculpture Hancock makes in the film,* Aphrodite at the Watering Hole, *has a wonderfully awkward sense of creativity about it, which is repellent and ugly whilst also being somehow beautiful. The beauty is partly Hancock's character himself. But whether he's cycling around on a canvas, or chipping away at Aphrodite, it's the fact that he doesn't quite know what he's doing, yet can still create works of genius, that has such an appeal. I think a lot of artists aspire to that sense of rawness, that there is something that, despite intellect and learning, can still possess a profound humanity. Somehow it seems the best way to get to that place is through irony and humour.*

ITS HEAD A MASS of whipped-up foliage green with tumescent tendrils, a being or object reminiscent of a Green Man woodland spirit of English folklore turns either toward or away from us. It is impossible to identify in which direction the critter faces. If toward us, then its 'chin' might be regarded as raised in pride, defiance, and defended self-worth. If, on the other hand, we are creeping up on it from behind, then its shoulders are slumped and its head droops; its entire body language is that of abjection. On studying the painting, one is inclined to presume the latter, that whatever presence this work transmits, the source is sorrow, tiredness, and a form of cosmic loneliness. But Brown's delight in ambiguity, coupled with his interest in those phenomena that have somehow become discarded and rejected, is translated through his painting into a haunting paean not only to the lonely but to that which has been outlawed for its lack of sophistication. For all we know, this humanoid blob of anaemic boiled spinach might be feeling reasonably perky.

In deepest California, an élite team of super-progressive cyberneticians and software designers has built a secret, somewhat exclusive generation of robots that are programmed to be sad and incompetent. These unhappy machines, activated by voice recognition, will, for example, carry out simple domestic tasks extremely badly—dropping things, breaking them, colliding with other objects, and often working very slowly. The robot will then ask, forlornly, to be graded on its performance on

a scale of 1 to 10, becoming audibly tearful as its faults are marked against it. Others will break down in piteous whimpers, collapse to the floor, and ask for assistance. As the artist, Independent Group member, and later futurologist John McHale once remarked about his work *Frankenstein by Way of IBM*, there is a dark conflation of technical brilliance, pathos, and cruelty. The same is true of Brown, by his own admission an operator in the reanimation of cultural cadavers: he offers artistic rehabilitation to the culturally homeless and aesthetically unloved, but in so doing is sometimes less than kind in his enthronement of these outcasts.

What, then, is the common temper of Brown's art? Looking at works such as *Architecture and Morality* and *Death Disco* (both 2004, pp. 115 and 117), one appears to be in some newfound artistic territory, perhaps a small island off the coast of Surrealism. There is austerity and strangeness, evident humour, and no small degree of gothic mystery. At the same time, the works seem to touch on aspects of British neo-Romanticism, while also being utterly at ease with Pop art *and* in league with postmodernism. Add to this an almost cartoonlike sensibility, as though Leonora Carrington had tutored with Hanna-Barbera. Such is Brown's formidable aesthetic circuitry, however, that there now seems to be the assurance to break free of all conceptual signage. Composition, colour, and form appear fluid, enabling the mutation of art-historical reference points to maintain an exquisite balance between figuration and abstraction.

His relation as an artist to the physical materiality of paint itself—as evidenced, also, by his sculptural works, most recently a paint-encrusted table, *The Sound of Music* (1995–2007, p. 83), that appears to be feathered with shards of bright colour—is similarly fundamental to the broader concerns of his art.

From the richly hued, epic science-fiction spacescapes to the meticulous, mutated reclamations of works by other artists, there is at times a further aesthetic relationship to the theology of kitsch, an original definition of which was more concerned with that which has been abandoned and thrown out than that which offends 'sophisticated' taste. In these latest paintings, some of which respond to the visual extravagance of highly romantic, quasi-classical scenes, one might be seeing the visual extrapolation of the thesis put forward by Celeste Olalquiaga in *The Artificial Kingdom: A Treasury of the Kitsch Experience*. Having distinguished between 'nostalgic kitsch' and 'melancholic kitsch', Olalquiaga observes: 'Nostalgic kitsch is a shrunken sign: it has been reduced to its most basic and benign expression. It is a phenomenon that denies both the present and the past in the interest of its own cravings, the only place where this kind of kitsch can firmly locate itself. Nostalgic kitsch is static, it doesn't move, it just oscillates back and forth between the glorified experience and its subject.' By coincidence, an earlier painting, *Oscillate Wildly* (1999), routes Olalquiaga's notion of nostalgic kitsch to Brown's appropriations of the work of Salvador Dalí, whom Brown

has described as being regarded in some circles as too populist to be represented in a sophisticated gallery. One imagines that such banishment is based upon the absorption of some of Dalí's works into mainstream commodity culture, into the currency of mugs, key rings, and posters mounted on the bedroom walls of thoughtful teenagers. The images themselves become somehow flattened out by the industrial processes of mass media and mass production. This, in its turn, raises further questions about the relation between 'high' and 'low' art forms in Brown's art, and the skewed, unpredictable dalliance between fine art and the forces of popular culture. For there is a sense in which the industrial commodification of Pop imposes a mechanistic levelling of image, creating a form of illegibility—invisibility, even—derived from the sheer scale of mass production. Brown's courting of repulsion, as well as pleasure, in response to his work suggests his delight in turning taste against itself, a stance that, in our present urban culture of excessive, pasteurised tastefulness, would appear to be usefully anarchistic.

As the retinal impact of Brown's painting derives foremost from his tireless love affair with paint itself, so the ensuing dark comedy of his work is played out between the forces of vulgarity and refinement, ugliness and beauty. Expressed through painting, these characteristics use a symbolic language of mortality; the whole becomes an extended, iridescent conceit, in which time, memory, death, and decay are set to perform their own gothic masque on the nature of art and aesthetics. Brown—like Wilde, perhaps—maintains the seriousness of his intentions by way of paradox, technical virtuosity, and no small amount of quotation. Both, too, are determinedly in the service of modernity, appalled as much as amused by the creeping quaintness that can afflict a stagnating culture. Brown, too, is, I guess, an über-aesthete—a connoisseur of detail and context for whom the defence of beauty lies often in administering to his art small, homeopathic doses of ugliness, awkwardness, and insult.

In his essay 'The Decay of Lying', Wilde writes: 'Art never expresses anything but itself. It has an independent life, just as Thought has, and develops purely on its own lines. It is not necessarily realistic in an age of realism, nor spiritual in an age of faith. So far from being the creation of its time, it is usually in direct opposition to it, and the only history it preserves for us is the history of its own progress.'

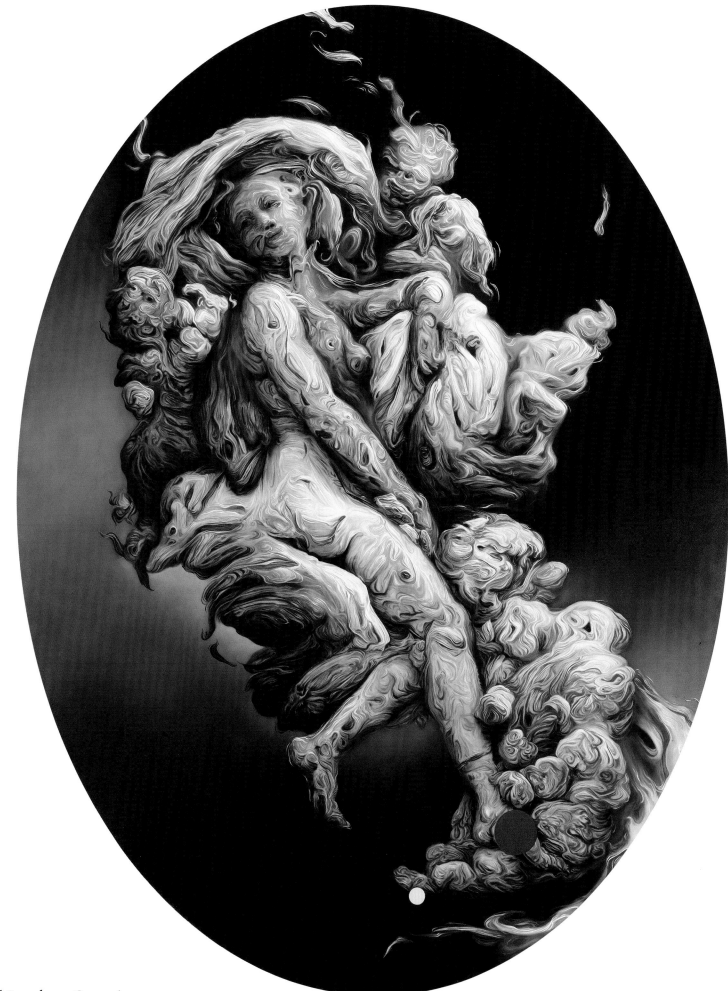

God Speed to a Great Astronaut 2007
Oil on panel, 162 × 122 cm (63¾ × 48 inches)

Suffer Well 2007
Oil on panel
157 × 120 cm
(61¼ × 47¼ inches)

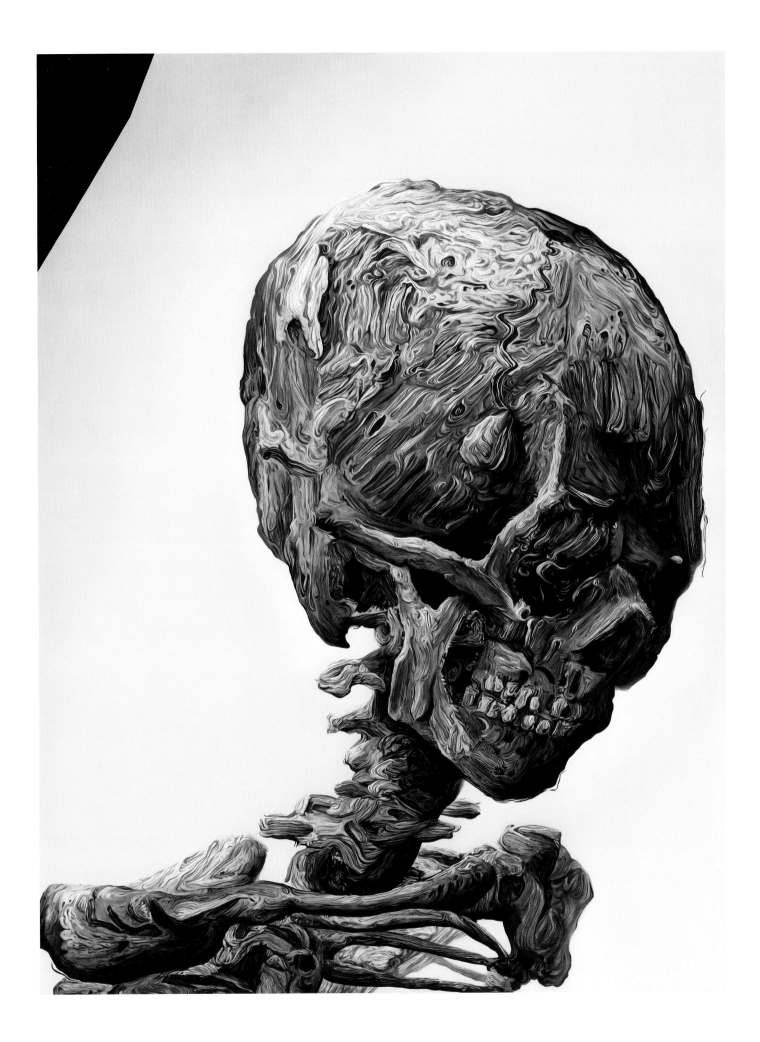

Wild Horses 2007
Oil on panel
133 × 102 cm
(52½ × 40¼ inches)

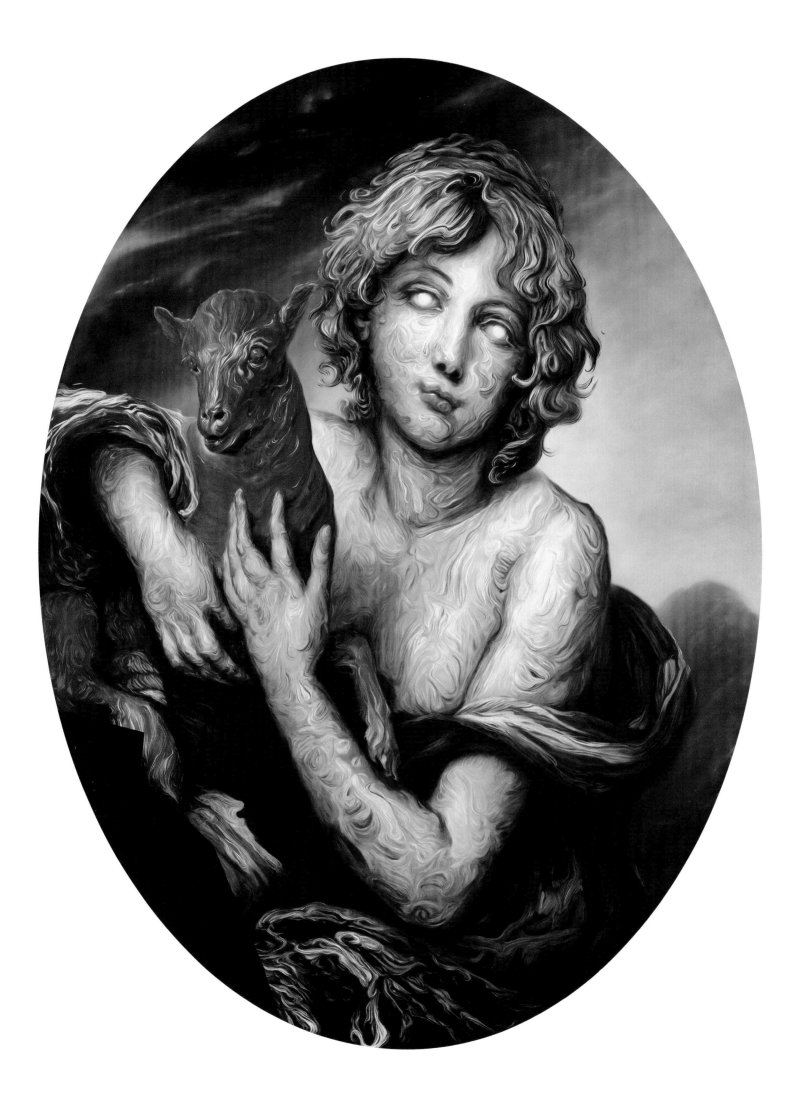

The Sound of Music 1995–2007
Oil paint on table
76 × 90 × 80 cm
(30 × 35 ½ × 31 ½ inches)

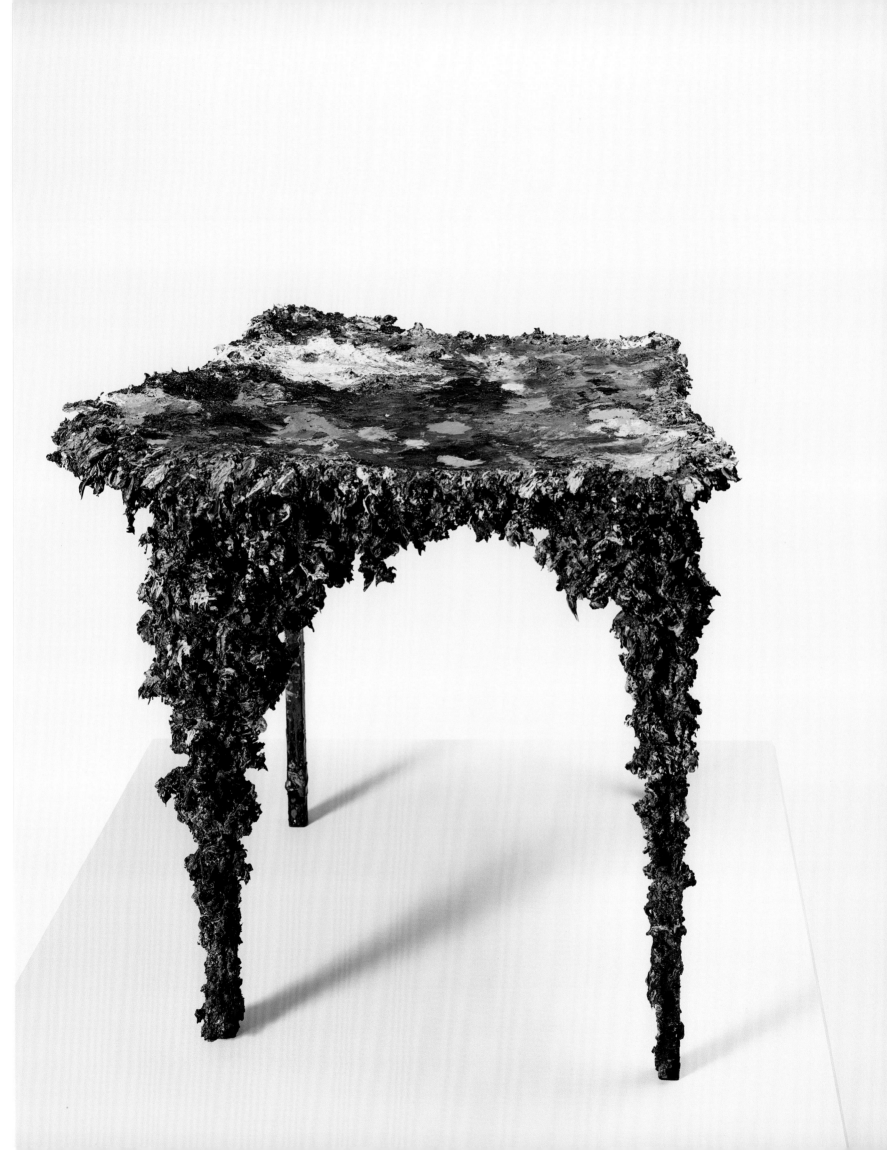

Deep Throat 2007
Oil on panel
152 × 122 cm
(59¾ × 48 inches)

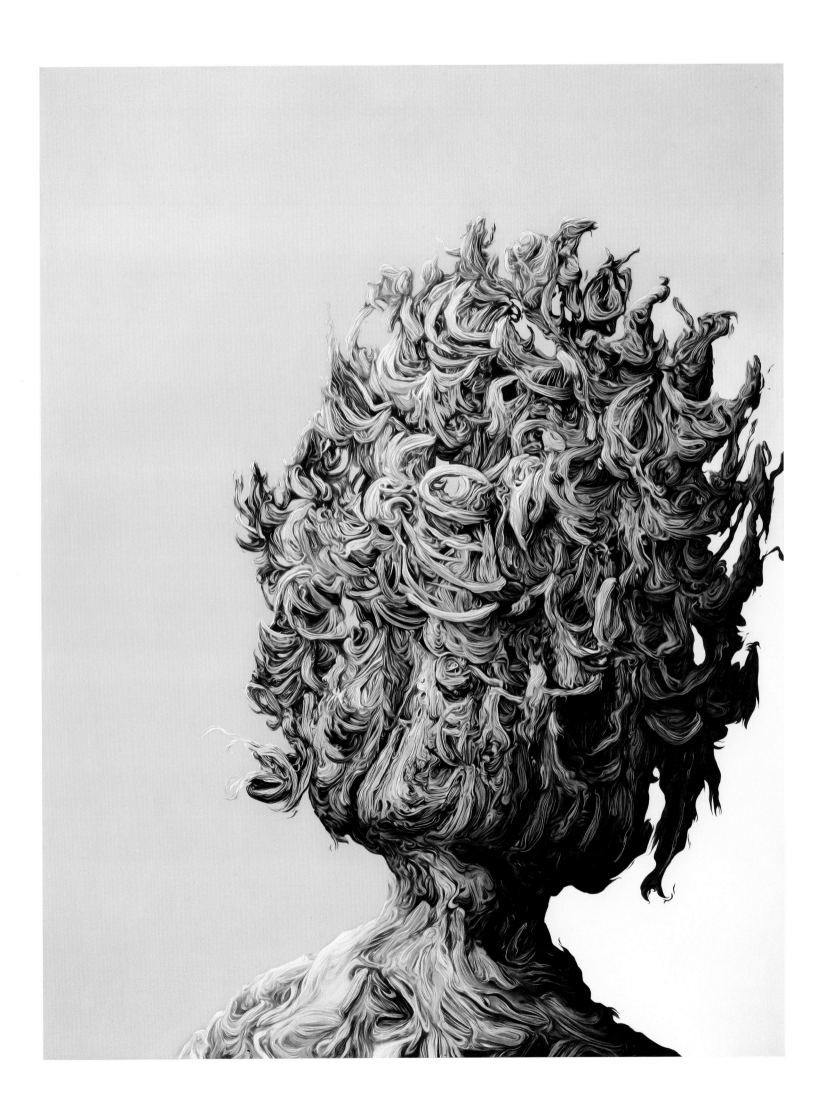

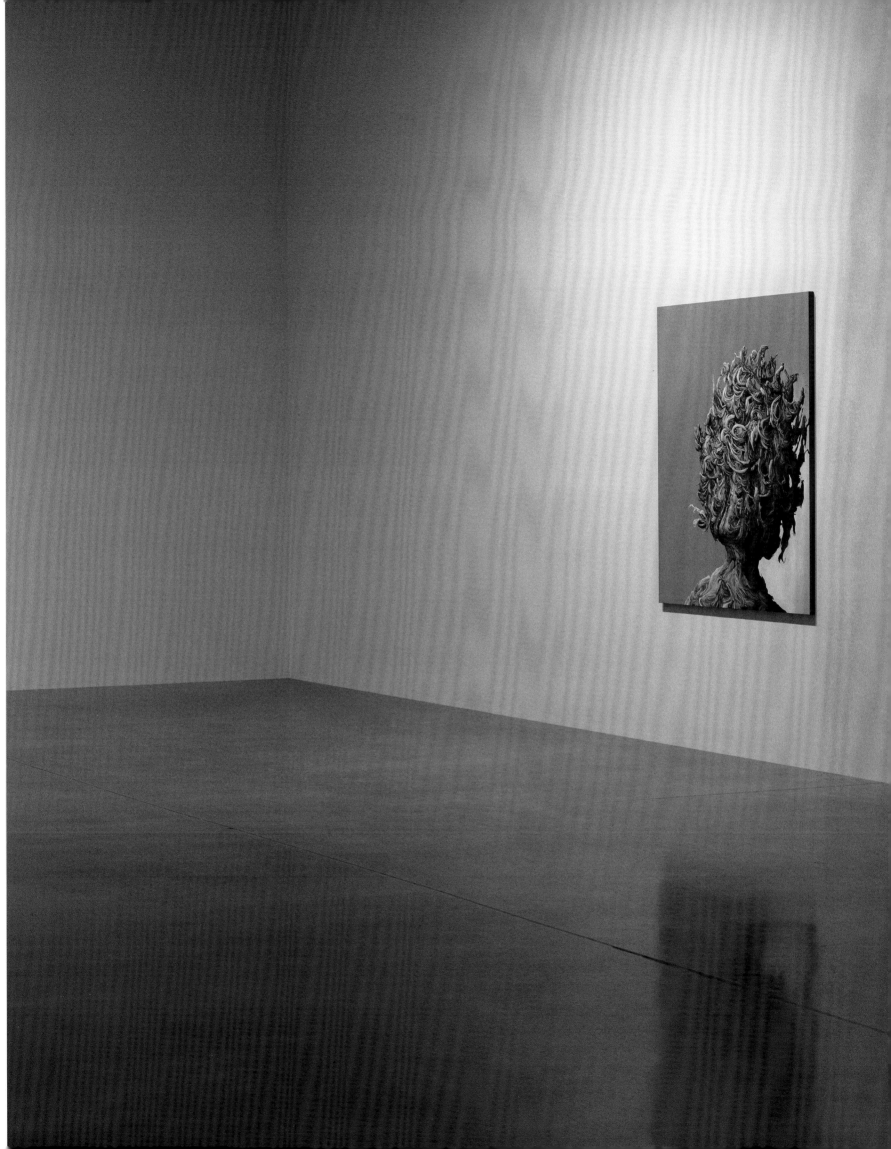

Senile Youth 2007
Oil on panel
122 × 156 cm
(48 × 61½ inches)

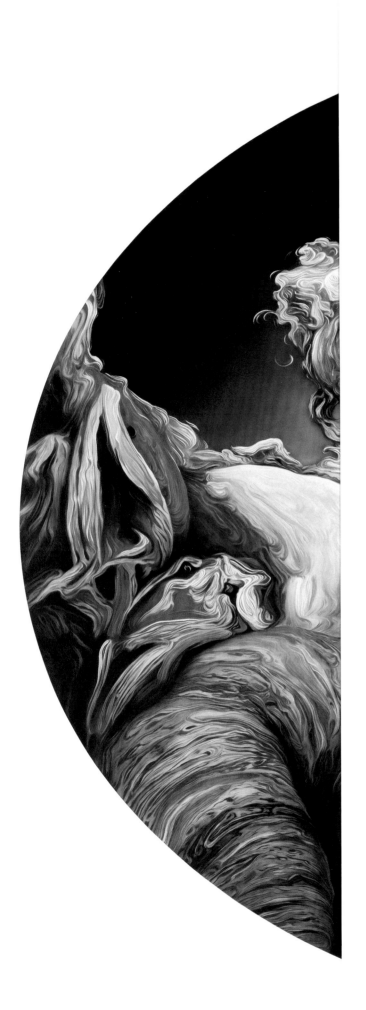

Life Is Empty and Meaningless 2005
Oil paint on acrylic medium and plaster on metal armature
82.5 × 76 × 43 cm
(32½ × 30 × 17 inches)

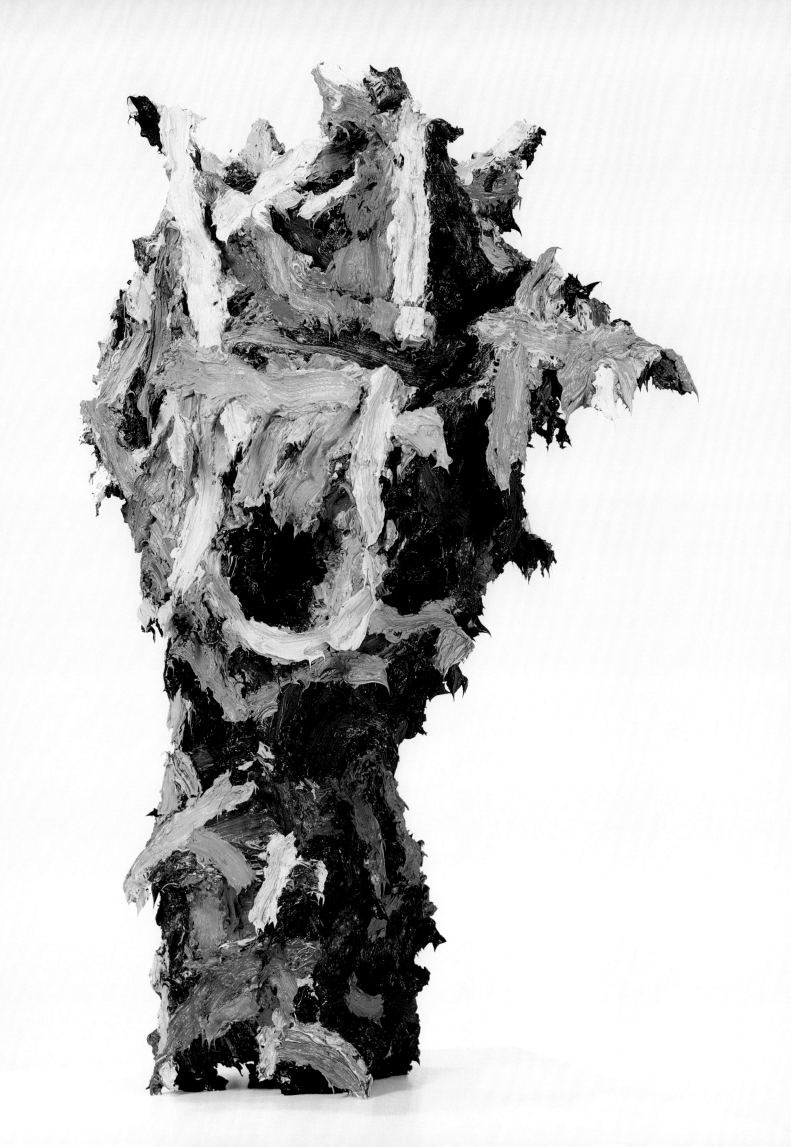

Polichinelle 2007
Oil on panel
130 × 106 cm
(51¼ × 41¾ inches)

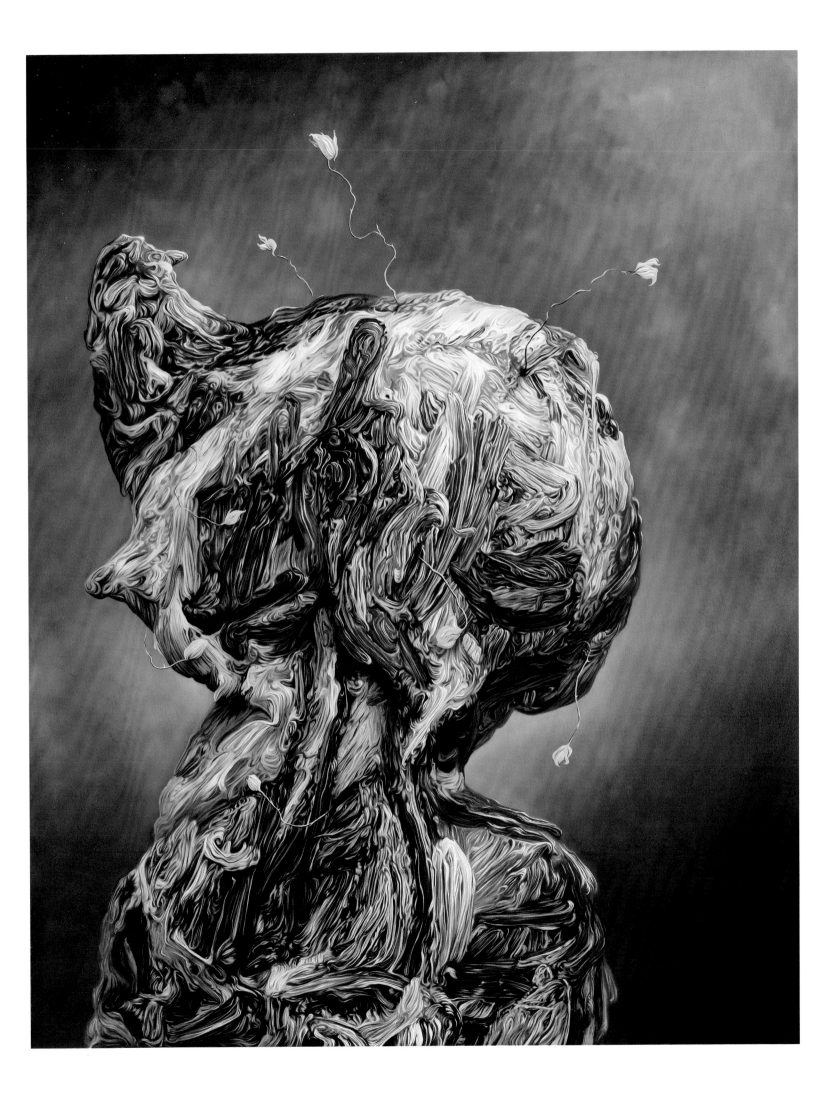

Tart Wit, Wise Humor 2007
Oil on panel
144 × 108.5 cm
(56¼ × 42¼ inches)

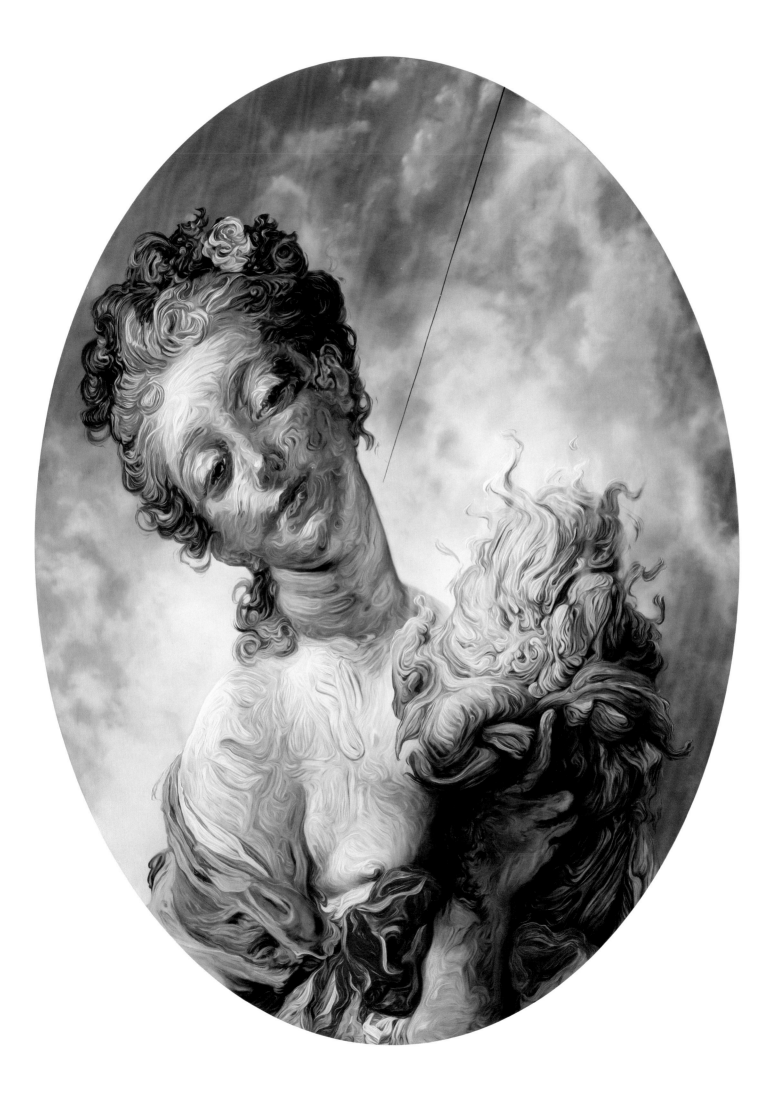

980 Madison Avenue, New York

25 FEBRUARY – 10 APRIL 2004

Against Cliché

Glenn Brown and the Possibilities of Painting

David Freedberg

PAINTING AS AN ART FORM HAS LONG BEEN declared dead, its possibilities often thought to be exhausted. But in this exhibition of his latest work, his finest and most mature to date, Glenn Brown raises the stakes. Irony and paradox abound. Consistency and elegance are quickly subverted in favour of more complex qualities. Brown's affection for the clownish and the pantomimic seems at odds with the internal coherence of the group of work in this show. The thoughtful and often pointed elegance of his installation belies his interest in kitsch. 'In all my works I want rich vulgarity and bawdiness', he has said; while the high seriousness of his paintings is unquestionable, so too is the humour—sometimes wry, sometimes banal, most of all ironic.

Yet these are possibly the least of the paradoxes that permeate Brown's work. They begin with his painterly technique. The bravura of his brushwork is astonishing: upon first impression, Brown appears to be one of the great exponents of the vigorous stroke, of brilliant impasto, of the thick and decisive line. But when you look more closely, you are brought up short. Here, on gleaming surfaces prepared with all the care and precision of an old master, everything is perfectly smooth. A kind of savage pictorial drama is achieved with the finest possible brush, leaving a surface so puzzlingly free of thick impasto that many spectators may feel that these are little more than prints or some other form of mechanical reproduction. The vigorous line is certainly there, and it is full of intensity; but the vigour is not achieved by means of thickly applied, almost palpable paint surfaces,

as in the case of almost all of Brown's models, from the old masters through contemporary artists. Where one would expect roughness and granularity, all is refined; no sharp and extravagant gestures, no jagged or blunt strokes, but rather a breathtaking accumulation of swirling lines, beautifully applied. Psychic drama gives way to cool skill—or so it may seem. Swiftly one realises that Brown has invented a new way of painting, in which intense pictorial action does not leave palpable traces of paint, either as indices of the artist's psyche or as a significantly expressive medium. These are strokes that seem uninflected by the signs of individuality. For all the traditional preparation of his pictorial supports (carefully gessoed panels, perfectly smooth layers of underpainting), one soon realises that Brown has set out to subvert the very bases of painting, and to undermine our expectations of it, both psychological and technical.

All this emerges clearly from Brown's copies of van Dyck, Rembrandt, Fragonard, and Baselitz in the present exhibition. But immediately another question emerges. Are these works really copies? Or are they adaptations of one kind or another? It is not at all clear how one is to speak of these works. As we shall see, they always manipulate their models quite extravagantly. They are neither transcriptions nor pastiches; to call them appropriations would be to describe them inadequately. That term turns out to be too cool for the significantly deconstructionist project in which Brown is engaged; in fact, the strategy is altogether different. Let us look at them one by one, before attempting to place them precisely.

Perhaps the most disturbing of all the paintings on display here, and possibly the most profound, is the work entitled *Sex* (2003, p. 127)—which, along with Death and Religion (that old trio), turns out to be one of the leitmotifs of the group as a whole. Based on van Dyck's portrait of Cornelis van der Geest in the National Gallery in London, the head has been so elongated (a characteristic move of Brown's) that most viewers, ignorant of the beautiful and moving original portrait from which it is derived, think that it comes from some painting or another by El Greco. But the manipulations of van Dyck's portrait go far beyond simple elongation. As always in Brown's work, the impasto of the original has been altogether suppressed and replaced by Brown's characteristic swirls of an exceptionally fine brush: they are labyrinthine, vermiculate, serpentlike, constantly mobile. Then there are the colours: the realistic flesh tones of the original turned blue, the brilliant white collar made yellow, and the dark background invested with the faintest suggestion of cold fire. In the midst of these unearthly hues, the only residue of living flesh is in the redness of the nose. It is so red that it reminds one of the clown figures that have always been so important to this painter's sense of ironic detachment from his sources of inspiration, indeed from the very history he reworks in his paintings.

There is something still more poignant in this work. The poignancy is obvious to any beholder, but it is probably even more so to those who are acquainted with van Dyck's painting of the Antwerp alderman. For in his version, Brown replaced with cataracts the liquid and expressive eyes of the original, tired though they may be. van Dyck's vivid eyes are now covered by a grey film, a visual caul, so to speak. The effect is altogether arresting: it confuses the beholder by signalling the failure of the very instruments by which we grasp and evaluate any work of art, and hints at Brown's deliberate strategy of veiling the literal and psychological depths of the expressive means of painting.

Facing this work, across the gallery, Brown appropriately placed his reworking of Rembrandt's *Flora* of 1634. This was a clever and pointed move, for in this picture also Brown did something strange to the eyes, turning the heavy-lidded, somewhat sluggish eyes of the original into a bloodshot gaze. That gaze now belongs to a picture entitled *Death Disco* (2004, p. 117), silently looking across at the blindness of *Sex*. These works are not just coolly ironic postmodern appropriations of ancient pictures; they generate narratives that are deadly serious, and invest whatever clownishness they may possess with mordant meaning—just like the comic fool in classic tragedy (with whom Brown sometimes says he identifies).

At the same time, Brown continues his exploration of the means of painting, and his severance of technique from the dramas of content and expression. Once more he elongates the original almost beyond recognition, suppressing the suggestion of pregnancy in Rembrandt's Saskia (his model for this *Flora*), and removing the shepherdess's *houette*, the sign of her pastoral calling (though he cannot resist exaggerating the droop of the giant tulip that falls from her garland). Above all, Brown proclaims

his colouristic inventiveness: he changes the muted tones of his Flora into the deep unnatural blue of many flowers in her hair, of the broad sash crossing her bodice, and he makes the background a brilliant yellow, purposely recalling van Gogh's famous painting of *L'Arlésienne* (*L'Arlésienne: Madame Joseph-Michel Ginoux [née Marie Julien, 1848–1911]*, 1888–89). It reminds one of that painter for whom, above all, the ferociously broad and impastoed stroke signified emotional drama and psychic turbulence.

No such equations, one might think, for *this* painter. And yet in the two paintings from Fragonard, colouristic modification combines with sheer breadth of brushstroke (however much the texture of these strokes may be annulled) in order to achieve both high drama and insidious meaning. Brown's version of Fragonard's so-called *Portrait of an Artist* (*Portrait de l'Abbé de Saint-Non*, c.1769) gains intensity not just from the massive strokes that make up the sleeves and collar of the sitter, but from the blue eyes, red hair, and even redder book set against the deep blue background, suggesting something of the heavenly and the divine; while the 'companion' portrait takes the French master's painting of Mme. Guimard and turns the relative modesty of the sitter—just as, perhaps, in the case of *Flora* and *Death Disco*—into something rather more challenging. Not only are the colours changed from fresh yellows and reds into rather lurid, even putrid combinations (the dyed hair itself makes the point), her gaze becomes altogether more pert, more obviously wanton. She acquires a prominent beauty spot,

and the modest blue-grey ribbon around her neck turns into a bright red one. This is not a ribbon in the end, but a death-cut. No wonder that in his installation, Brown chose to have this work, appropriately entitled *Filth* (2004, p.125), 'look away' from the male portrait entitled *America* (2004, p.113). The relation is both knowingly witty and ironic.

At this point, these qualities multiply. It is not only that the darkly atmospheric, almost celestial setting is given to the heroic personification of America (rather than being related to the divine inspiration of the artist), and that the innocent female sitter becomes filthy; it is that the smooth slickness of the surface altogether subverts the showy gesturalism of the stroke, just as in every other work in this exhibition.

This fundamental irony emerges nowhere more clearly, I think, than in the difficult painting called *Dirty* (2003, p.121). It is the one painting in the show wherein the reference to the savage and massively complex brushwork of the British painter Frank Auerbach is overt. While no one could doubt Brown's constant pictorial allusions to the ways in which painters like Appel, de Kooning, and Baselitz used similarly vigorous strokes to represent and model the forms on their canvases, Auerbach has long been his favorite source for appropriation and readjustment. In turning the heavy brushwork into a surface that is as flat as a photograph (or, say, like a work by Gerhard Richter), Brown here offers one of his fullest critiques of the indicia of the stroke and its authorial freightedness.

At first sight, the exceptionally broad strokes used to delineate the bone structure of the face and to expose the tendons and sinews of the neck and underside of the jaw—in striking contrast to the fine halo above this head—may put one in mind of the great flayed oxen of Rembrandt or Soutine. But where their brushwork is thick and heavy with a willed sense of fleshliness, Brown typically suppresses all signs of just these indicia, whether physiological or authorial. What remains of flesh here is the pinkness suffusing the whole picture, a colour Brown has said comes from Monet—of all painters.

Once more colour does its significant work, perhaps even more than density of medium; even so, the painting remains compelling because of the ways in which viewers seek to form (or rather re-form) the features within the picture, as if engaged in the act of modelling itself, finding the form one moment and losing it to another, newly found one the next. Brown has himself acknowledged of works such as these that 'I allow images to come and go as I keep on painting; it's like pulling a form in clay'.

In a brisk and critical review of the famous 1995 exhibition of paintings by de Kooning, Brown wrote that 'the curators have seen fit to designate the figurative against the abstract, and consequently fly in the face of de Kooning's considered metamorphic confusion'. Here Brown could almost be speaking for himself. His works are not simply figurative, as they might seem at first sight, nor ought they only to be judged as such. The notion of 'considered metamorphic confusion' applies just as well

to the iconographic and formal complexities of his own work. Brown has himself spoken to me of the pleasure he finds in hearing how spectators spontaneously discover forms within his work of which he may himself have been unaware, or may not have intended.

It comes as no surprise, then, to find that Brown especially admires the work of Giuseppe Arcimboldo, the mad painter from Prague, who embedded faces in fruit, flowers, and vegetables, and fruit, flowers, and vegetables in faces. The most overtly Arcimboldesque of the paintings here is the work entitled *Architecture and Morality* (2004, p. 115), where face and head are supplanted by a bouquet of yellow and white chrysanthemums (taken from Fantin-Latour) and placed on the body of a figure reworked from a double portrait by Lucian Freud.

Such overtly surreal juxtapositions are unusual in Brown, although in this case they do offer a kind of homage to the archetypical painter of flowers as heads; but there is, in fact, a difference. It is brought out most strongly in a number of other works in the exhibition, most notably *The Osmond Family* (2003, p. 131). In Arcimboldo's heads, the spectator realises that there are features *within* his heads with flowers (or fruit, vegetables, or implements), just as Brown's powerful adaptation of Georg Baselitz's *Second P.D. Foot—Old Native Country* (*Zweiter P.D. Fuß—alte Heimat*, 1960–63), it does not take long to discover first the eye sockets, then the bony nose, and finally the mouth of the skull-like form embedded within this foot. Then one notes the cut—what I earlier called the death-cut—within that

foot. This is no everyday limb; or perhaps it is indeed everyday, but it is also, somehow, holy.

Most of the titles (and sometimes the content) of these works almost instantly suggest their moral dimensions. This applies not just to the overt but enigmatic *Architecture and Morality*, but also to the suggestive trio of paintings entitled *Sex*, *America*, and *Filth*; and *Dirty* has a fine halo over its head, a halo so fine that it pictorially mocks the heavy strokes of the rest of the work. At the same time, this halo also ironises—or does it sanctify?—the title. 'Are you constructing morality within your world?' Stephen Hepworth asked Brown in an interview in 2000. 'I'm discussing it', replied Brown, perhaps too tersely. 'I don't believe there is one doctrinal correctness. The humorous irony is that I am an atheist using painting, a language constructed largely via Catholicism.' In fact, Brown knows that painting has always 'been about religion and imaginary tales', as he put it in the same interview. In the case of Baselitz's *Second P.D. Foot*, Brown turns it into a picture that not only falls squarely into the history of religious painting, but actually partakes of the nature of a Christian icon. He gives it the title of *The Osmond Family*, that most scabrous of popular subjects (for popular sentiment has always been a major concern of his).

This is no merely haphazard title, however. To begin with, Brown works his usual transformation of his archetype. He elongates the truncated foot, sets it majestically upright (thus making it something iconic), adjusts the colour scale in a way that recalls Philip Guston, and sets it against a pale blue punctuated with black and red stars. The setting, though once more derived from van Gogh, recalls Brown's earlier science-fiction work, but at the same time gives the foot a truly celestial context. For surely this is none other than Christ's bloodied foot, punctured and cut from the Crucifixion, set against the heavens. The acknowledged source may be Baselitz, but the inspiration is clearly Grünewald, and more specifically Grünewald's Isenheim altarpiece, where Christ's limbs are broken, punctured, and cut, just like this foot. The painting here, smooth and slick though it may be, suggests blood, flesh, and death; it could not be more carnal in its combination of pinks, reds, yellows, and blues, or in its suggestion of fleshiness and vulnerability. For the wounds (*vulnera*) are there; and so too is the face, making the Christological reference even clearer: this is a picture of nothing so much as the reincarnation of the body, in all its carnality.

There is still more to this fragment of the Passion, however. Embedded in the flesh are not just the wounds and the skull (recalling the skull buried at the bottom of the Crucifixion, and pointing forward to the resurrection of the flesh), but also the dirt and grime that became engrained in his flesh on the way to the Cross, and with which his mockers tormented him, rubbing dirt into his divine wounds. The title of this painting embodies the clowns—that is, the people themselves—who mocked him, and who turned his Passion into something lurid, ludicrous, and in the end powerfully symbolic. This insistence on the gravity and import of vulgar clownishness

pervades all of Brown's work. It is in just this light that we must also turn to the sculpture (though Brown would not call it that, precisely) *Three Wise Virgins* (2004, pp. 128–29).

Here, of course, the title is explicitly religious. It alludes not just to the Virgin, as Brown has said, but also to the biblical parable of the Wise Virgins who took enough oil for their lamps to watch for the coming of Christ. But each of these Wise Virgins has a clown's nose; one even has the horns of a devil coming out of her head. In its combination of whimsy and ferocity, this work recalls the early sculptures of Picasso, with their protruding mouths and noses and hollowed-out eyes. As we pick our way through the now all-too-palpable layers of thick oil paint that make up this sculpture (Brown would prefer to call it a painting) and find one head after another (just as Brown wants us to), we begin to sense the devilish in these clowns. Here we see an awful grin, there a red mouth, and frightening features all round. Thus do these wise virgins become mockers of Christ, not merely three faithful devotees.

As if to crown these vulgar yet profound ironies comes the sculpture/painting entitled *Alas Dies Laughing* (2004, pp. 122–23). Here too there may be a further religious allusion—this time to the severed head of John the Baptist. Brown has himself indicated that the block of wood on which he has so strategically placed this head alludes to the executioner's block. Though this work too pays a kind of homage to Baselitz, it is hard not to think as well of Brancusi's similarly shaped sculptures *The*

Beginning of the World, carved between 1916 and 1924. These, however, are works of an extraordinary degree of smoothness, gleam, and polish, whether in bronze or in marble. And Brown's rough agglomerations of paint offer a kind of critical commentary on them, in a precise inversion of his usual transformation of textured and impastoed paint surfaces into light and liquid smoothness.

It is hard not to think of the disc on which Brancusi placed his originary sculpture, *The Beginning of the World*, as signifying the orbs of the cosmos. But Brown's sculpture has no such claim; on the contrary. This *Alas* is a final laugh in the face of death, a sign of the life that is avowedly embodied in all of Brown's work, the life that he encourages spectators to find both in the impossibly flat pictures and in the all-too-fleshly sculptures. For these are such palpable pilings-up of paint that we want to touch them, to poke our fingers in them, to provoke them into response or liveliness—even in the case of this severed head. In this way, these three-dimensional works—great quantities of paint applied to armatures of wire and plaster—offer a pointed commentary on the two-dimensional paintings in the exhibition. The latter paintings deny all surface, suppress the gestural marks of authorship; the former reveal all of them and visibly and palpably insist on the substantiality of paint. Yet Brown persists in calling these works paintings, as if to push paint back to the two-dimensionality with which it has always been invested.

These new works of 2003 and 2004, then, are self-assured in their high intellectual and technical consis-

tency. Brown has moved away from the science-fiction paintings of earlier years, as well as the almost obsessive reworkings of Auerbach (he saw their thickly textured surfaces as akin to that of the moon, which he had also painted for several years). The relative indecisiveness of his technical goals in his earlier derivations from Fragonard and Rembrandt (as well as, occasionally, from Richter) has now been honed into a masterful and inimitable—if occasionally repellent—style of painting. Above all, it has become clear that the apparent appropriations of earlier and contemporary artists are not really 'appropriations' at all, at least not in the usual postmodern sense. Indeed, they reclaim many of the elements of painting in order to put some of the claims of painting back into the world. But in so doing, Brown offers a fierce critique of a longstanding view of what painting can achieve, and substitutes for this traditional view a new and wholly innovative one, both theoretically and technically.

So how is one to position Brown's work, with its abundant irony, sharp wit, and high skill, or rather a set of skills that seem to be masked before revealing themselves in their full complexity? How is the work to be seen in relation not only to high culture, but also to the world of the popular and the vulgar?

Brown's transcriptions of other painters, as Keith Patrick has put it, 'have generally been taken in the context of postmodernism, where his transformation of seemingly gestural painterliness into a flat, painstakingly constructed surface is seen to raise issues of authorship

and originality, and to refer to the ways in which our experience of "the original" is all too often mediated by the photographic reproduction.' 'Ironically', Patrick concludes, 'this distinction is lost in reproductions of Brown's work, re-establishing the need to confront his original paintings.' Indeed. For as Mark Sladen has concluded, 'Brown may indeed be engaged in a postmodern critique, but the finessing in which he engages has a curious relationship to any such critique—implying a recuperation of individual agency at the limits of what can be understood as authenticity.'

This seems altogether right to me. Traditional notions of authenticity are clearly at risk—to say the least—in Brown's work, and are intended to be so; but at the same time, Brown is making a series of statements about the traditional possibilities of painting that culminate in a fierce critique of how we understand just those possibilities. He himself has noted that the term *appropriation* 'has been much maligned and misunderstood.' It's a term, he insists, 'that seems to only express a certain conceptual framework and obliterates any painterly or aesthetic understanding involved'. And this understanding has as much to do with painting itself as with Brown's insistence on the popular and vulgar aspects of his work. He admires the gorgeous vulgarity of Jeff Koons; he wants to make work 'that has popular sentiment but involves deconstruction of images'. Over and over again Brown emphasises the importance of bawdiness and buffoonery through the figure of the clown, because clowns are both popular and unsettling. He wants humour, and

above all black humour, in his work because this is one way, he believes, to access the emotions. Brown finds these qualities in the work of artists like Picasso, George Condo, and finally Velázquez, whose buffoons in the Prado he describes as 'wonderfully upsetting, tragic, and black'. He loves museums, because they are like going to the movies, he says, a place 'for high drama and great acting, for the history of the world to unfurl in front of you.'

In the end, this is a high claim for painting. But Brown does not shrink from it. As he says (and as the old cliché goes), he wishes 'to breathe life into these empty vessels'. He wants pictures that have 'personal allusions to my own life and onto which I can project personalities of people I know'. As if a member of the crowd, Brown reflects on the fact that for him, 'the Auerbach, Karel Appel and Jean-Honoré Fragonard paintings weren't just empty subjects, but people; and that almost came on me unaware and took me over'. Brown has no reluctance to anthropomorphise, to imagine life into the portraits he copies, emulates, or invents. He also has great tolerance for popular responses to works of art—and paintings in particular—which make of them things to project imagination and desire upon, to see in them whatever the spectator likes. He himself incorporates such a view into his own work process, allowing images to come and go as he keeps on painting.

And so we come to the final paradox, or rather the paradoxical reconciliation. The works in this exhibition are appropriations that are not appropriations, transcriptions that are much more than transcriptions. Brown invests his work with dramatic content and sophisticated painterly skill, and in turn uses these skills to overturn the traditional ones associated with painting. As we have already seen, Brown remains profoundly critical of the way in which art history has rewritten itself, at least in the past four hundred years or so, in order to give prominence to artists like Rembrandt and van Gogh (to say nothing of Auerbach), in whose works the very texture and gestures of the brushwork are supposed to reveal the artist's soul. This notion of the expressive brush has become a fashionable cliché about painting. It is one that Brown has been consistently determined to work against and to resist as fiercely as possible. Yet he is not at all opposed to sheer dexterity. 'My desire to paint with detail and dexterity is due', he bluntly proclaims, 'to the fact that it is seen as bad taste. To use skill and craftsmanship is vulgar to the art establishment.'

Painting is reclaimed precisely because it is popular, not high; because it is vulgar, emotional, and fraught with humour, black and bawdy. Brown has found new functions for painting in the face of the modernist cliché that invests pure form with content, and against the grain of postmodernist strategies of appropriation without content. He has set painting free on a new road. It is avowedly not the high road, but there is much to explore along the way.

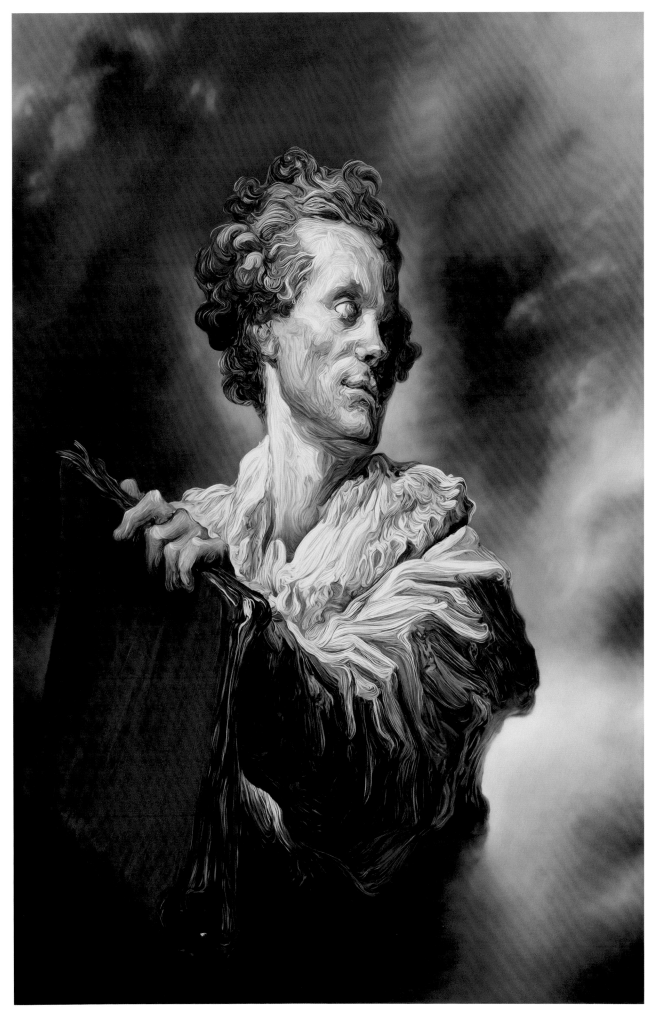

America 2004, oil on panel, 140 × 93 cm (55 × 36½ inches)

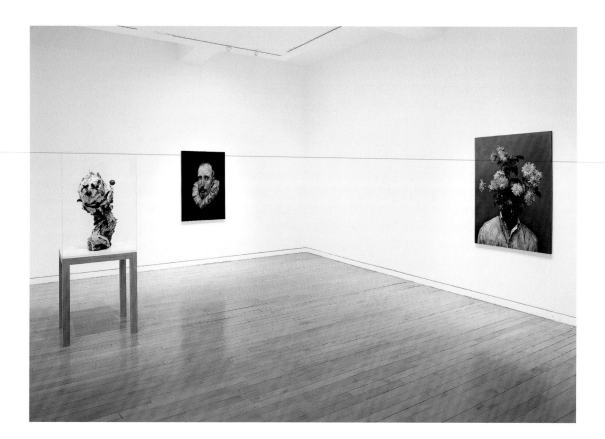

Architecture and Morality 2004
Oil on panel
140 × 98 cm
(55 × 38 ½ inches)

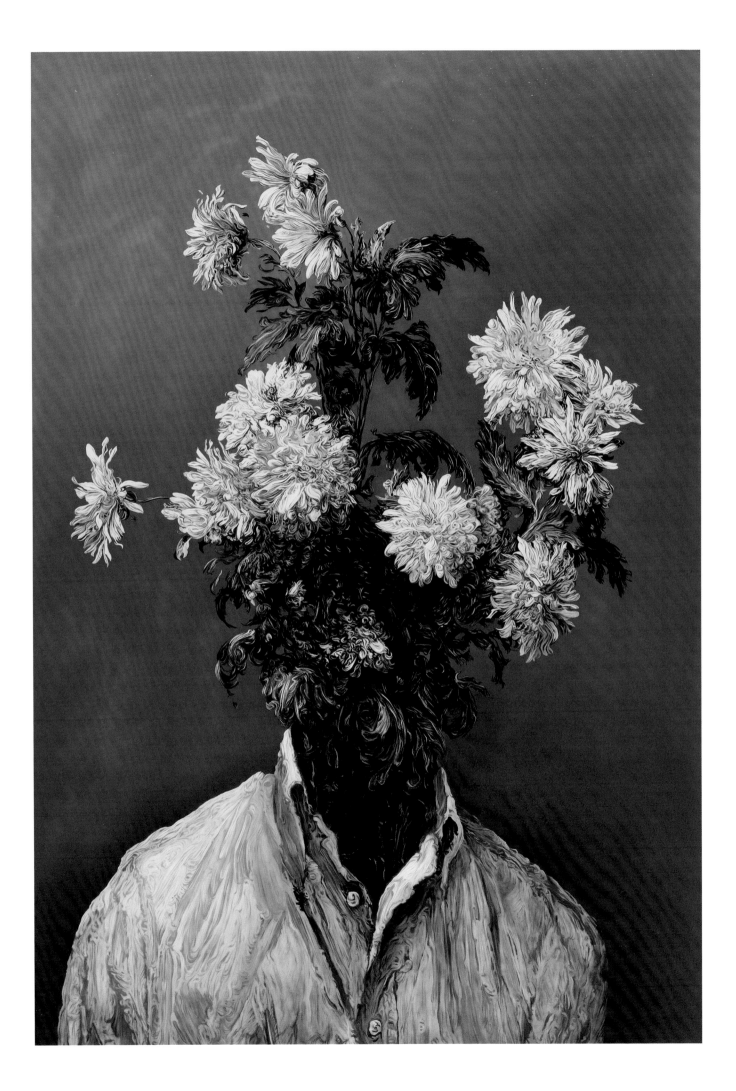

Death Disco 2004
Oil on panel
134 × 89 cm
(52¾ × 35 inches)

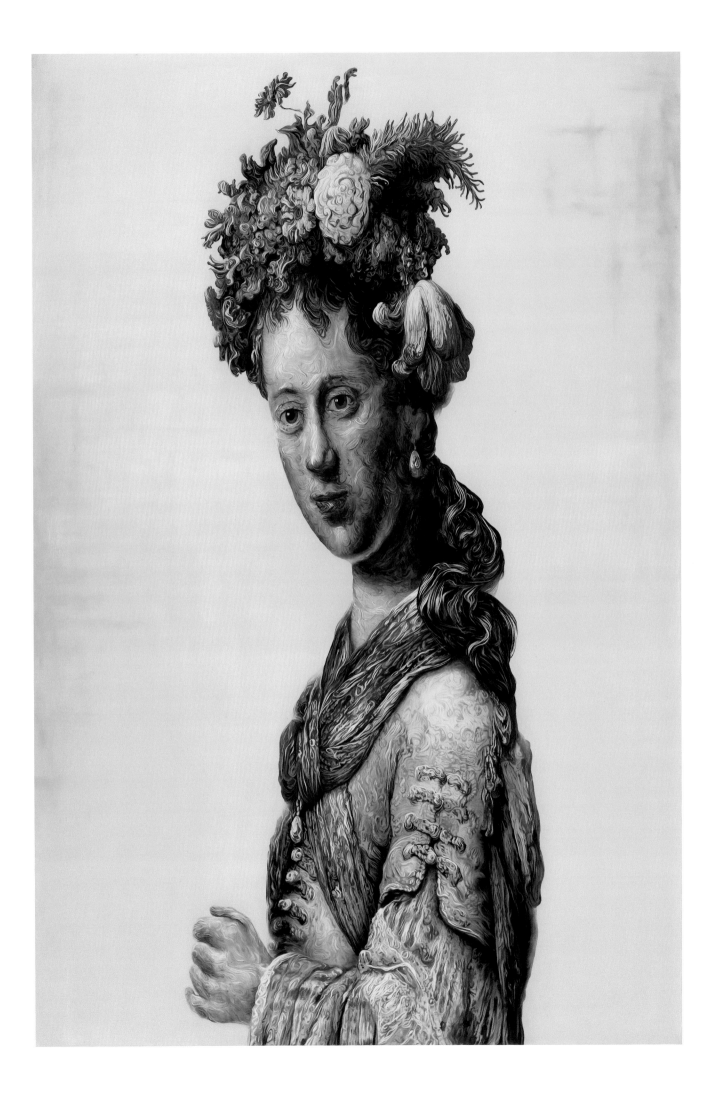

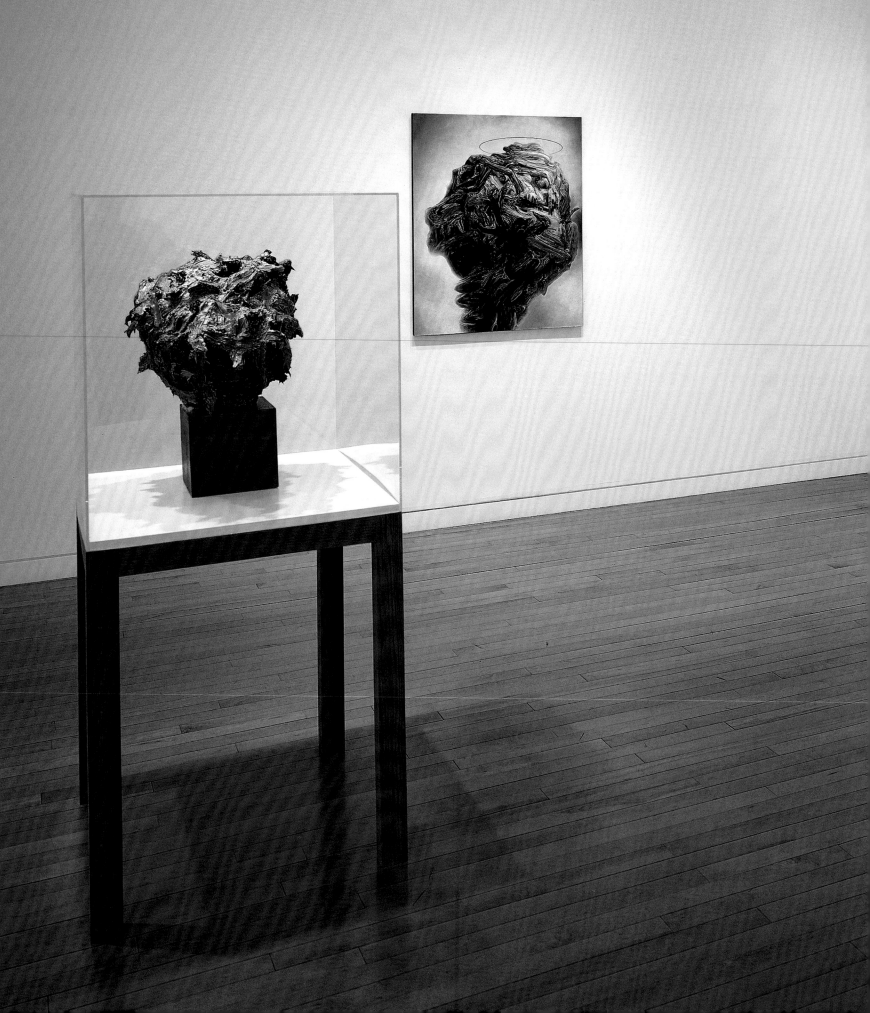

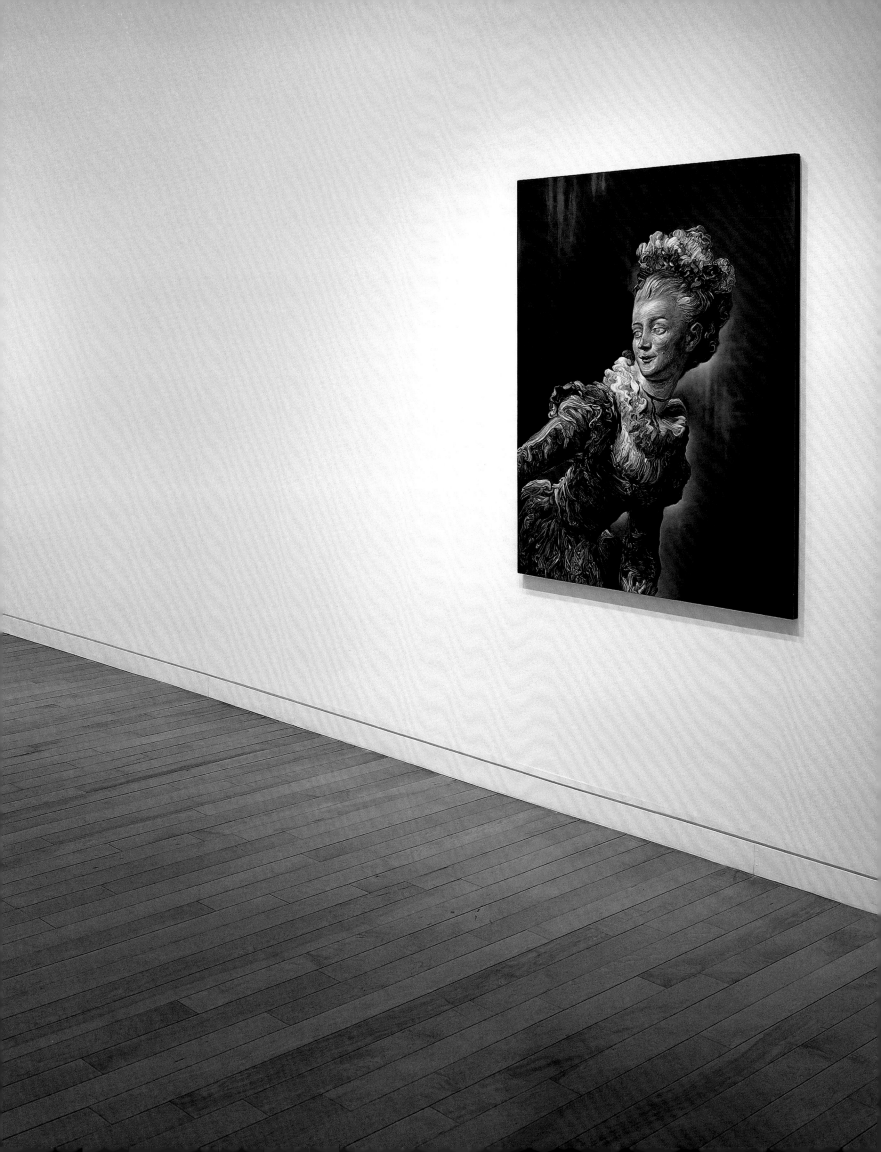

Dirty 2003
Oil on panel
105 × 83 cm
(41¼ × 32¾ inches)

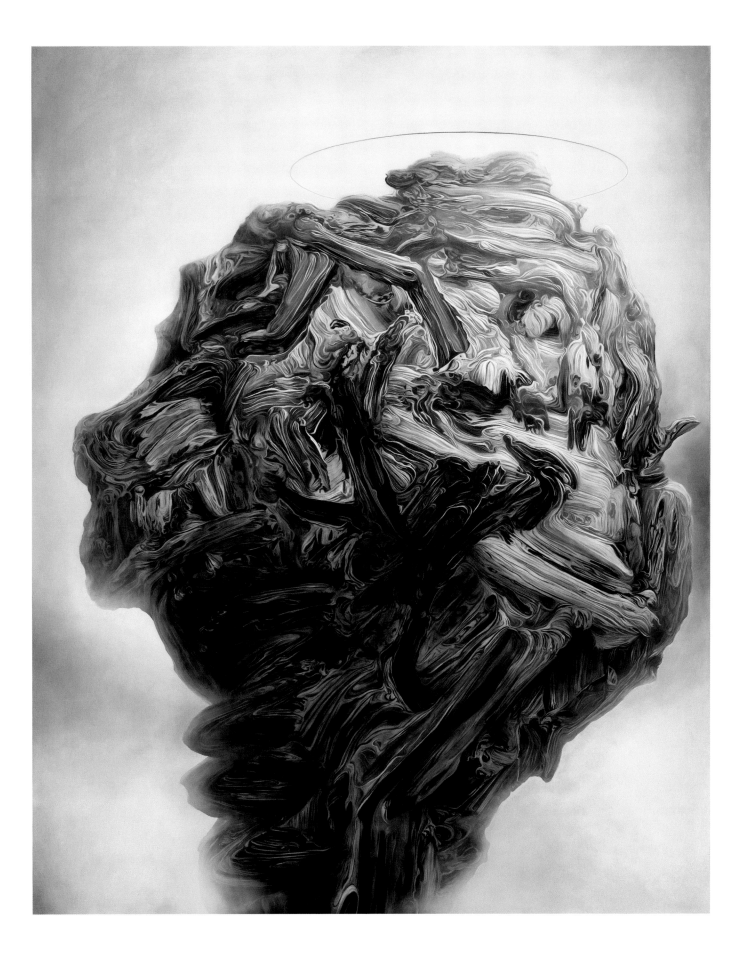

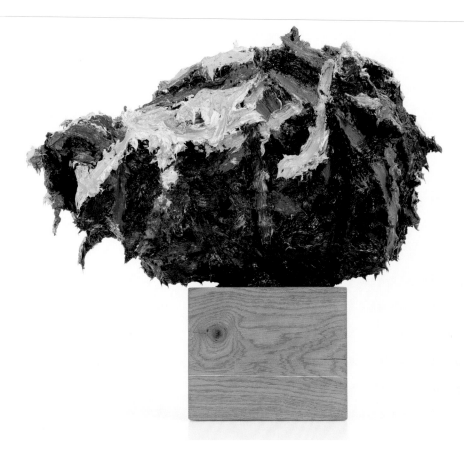

Alas Dies Laughing 2004
Oil paint on acrylic medium and plaster on metal armature
60 × 75 × 46 cm
(23¾ × 29½ × 18¼ inches)

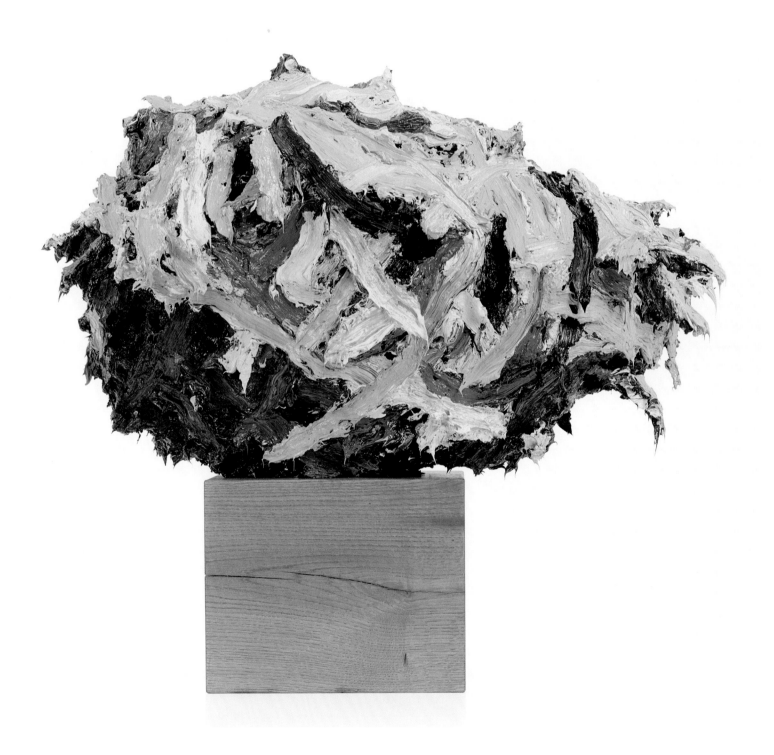

Filth 2004
Oil on panel
133 × 94 cm
(52½ × 37 inches)

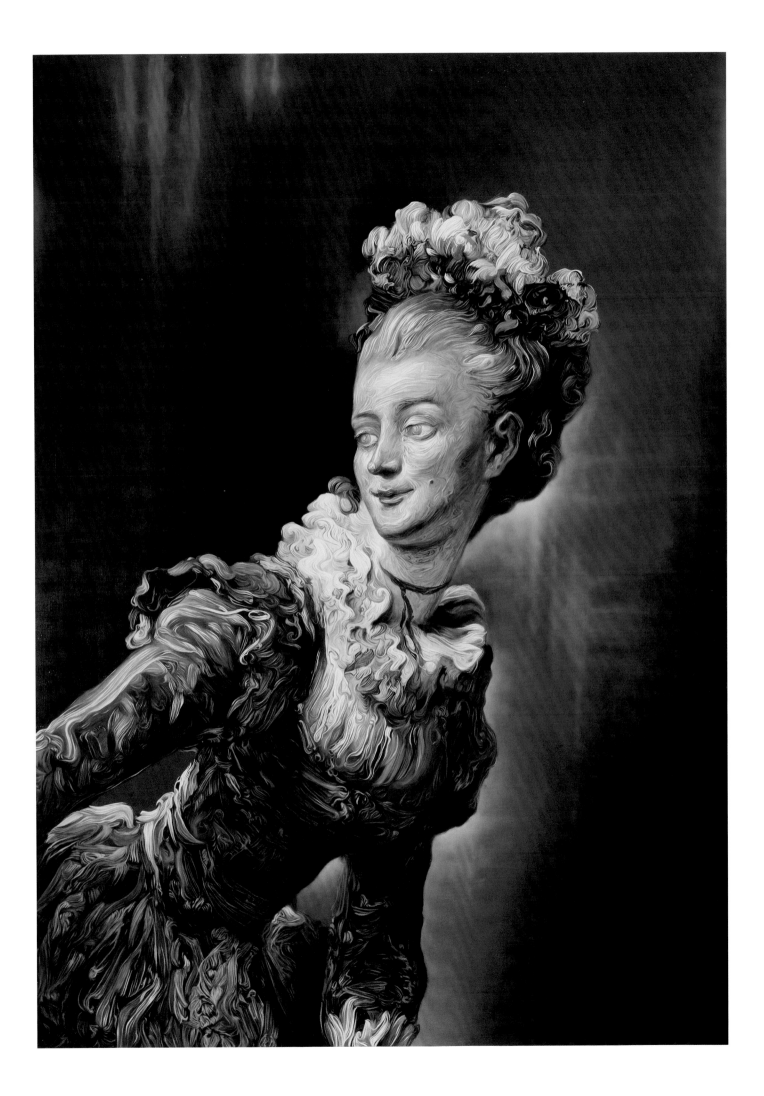

Sex 2003
Oil on panel
126 × 85 cm
(49¾ × 33½ inches)

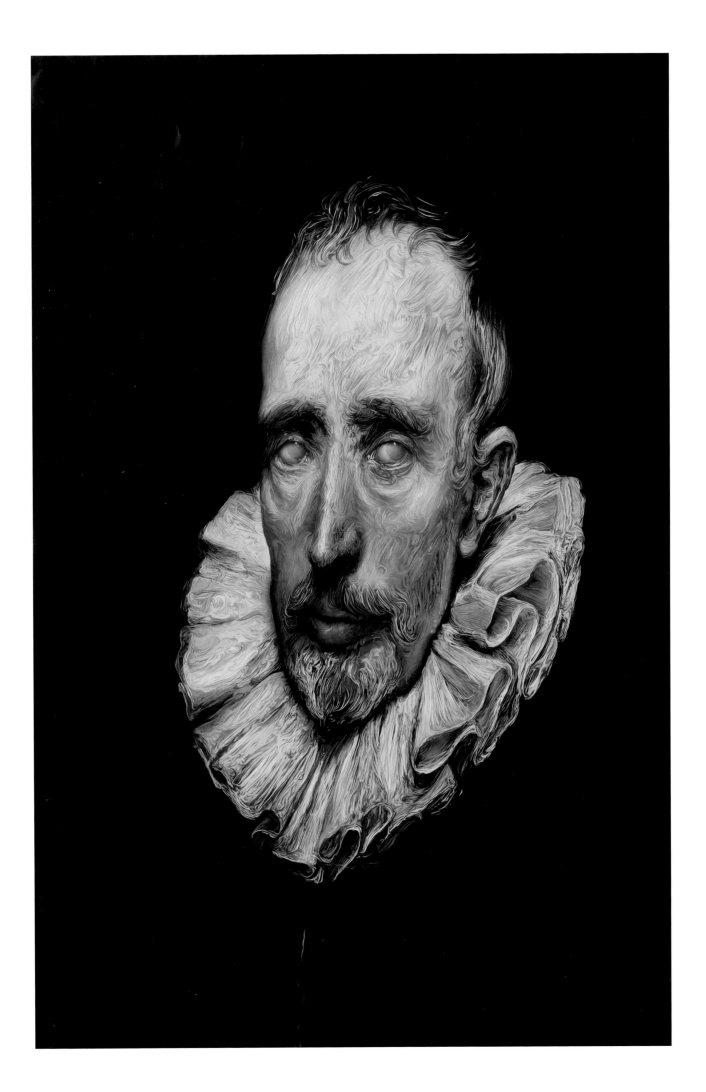

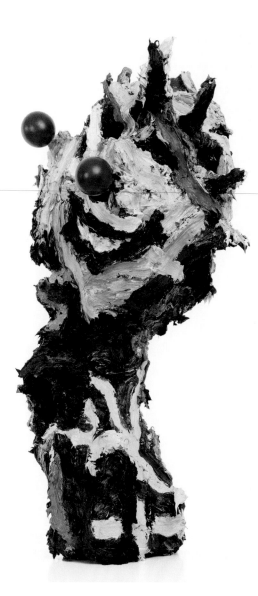

Three Wise Virgins 2004
Oil paint on acrylic medium and plaster on metal armature
85 × 55 × 55 cm
(33½ × 21¾ × 21¾ inches)

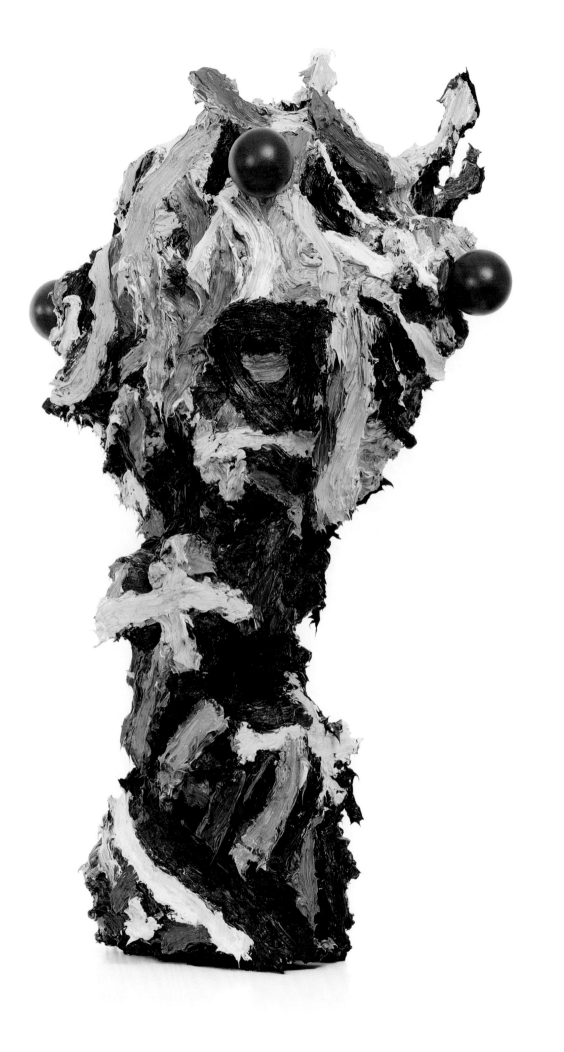

The Osmond Family 2003
Oil on panel
142.5 × 100.5 cm
(56¼ × 39½ inches)

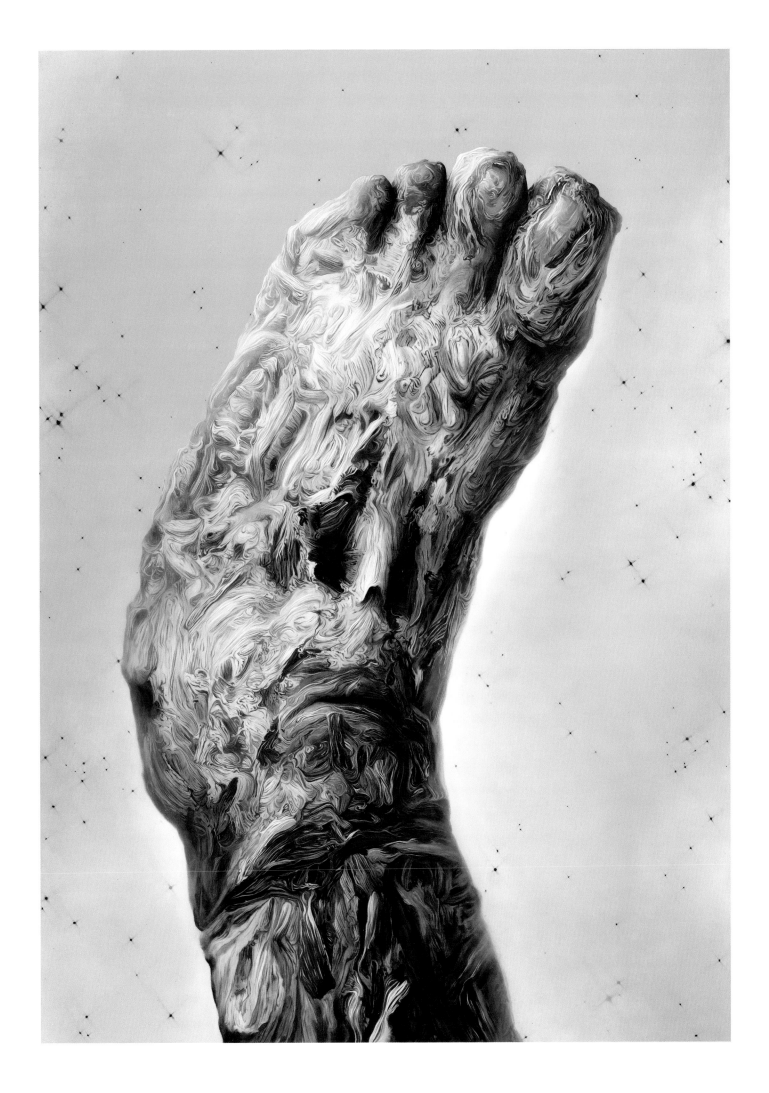

List of Works

The Great Queen Spider 2009
Oil on panel
150 × 120 cm
(59 × 47¼ inches)
PAGE 17

Song to the Siren 2009
Oil on shaped panel on steel support
250 × 148 × 18 cm
(98½ × 58¼ × 7 inches)
PAGE 35

The Organ-Grinder 2009
Oil paint on acrylic medium on metal armature
97 × 77 × 58 cm
(38¼ × 30¼ × 22¼ inches)
PAGES 18–19

Come All Ye Rolling Minstrels 2009
Oil on panel
140 × 109 cm
(55 × 43 inches)
PAGE 37

Star Dust 2009
Oil on panel
154 × 122 cm
(60¾ × 48 inches)
PAGE 23

Monument to International Socialism 2009
Oil paint on acrylic medium on bronze
38 × 52 × 37 cm
(15 × 20½ × 14½ inches)
PAGES 38–39

Spearmint Rhino 2009
Oil on panel
194 × 260.5 cm
(76½ × 102½ inches)
PAGES 25–26

After Life 2009
Oil on panel
138 × 114 cm
(54¼ × 45 inches)
PAGE 41

Christ Returns to the Womb 2009
Oil on shaped panel on steel support
269 × 152 × 18 cm
(106 × 59¾ × 7 inches)
PAGE 29

War in Peace 2009
Oil on panel
116 × 87 cm
(45¾ × 34¼ inches)
PAGE 43

If you know how to get here, please come 2009
Oil paint on acrylic medium on metal armature
147 × 50 × 41 cm
(58 × 19¾ × 16¼ inches)
PAGES 30–31

Wooden Heart 2008
Oil paint on acrylic medium on metal armature
89 × 148 × 70 cm
(35 × 58¼ × 27½ inches)
PAGES 45–46

Debaser 2009
Oil on panel
100 × 75 cm
(39½ × 29½ inches)
PAGE 49

Burlesque 2008
Oil on panel
121 × 220 cm
(47¾ × 86½ inches)
PAGES 51–52

Soul Disco Ambient Funk 2009
Oil on panel
98 × 71.5 cm
(38½ × 28 inches)
PAGE 55

Youth, Beautiful Youth 2008
Oil on panel
153 × 121 cm
(60¼ × 47¾ inches)
PAGE 57

Christina of Denmark 2008
Oil on panel
165 × 119 cm
(65 × 47 inches)
PAGE 59

Nausea 2008
Oil on panel
155 × 120 cm
(61 × 47¼ inches)
PAGE 63

God Speed to a Great Astronaut 2007
Oil on panel
162 × 122 cm
(63¾ × 48 inches)
PAGE 75

Suffer Well 2007
Oil on panel
157 × 120 cm
(61¾ × 47¼ inches)
PAGE 77

Wild Horses 2007
Oil on panel
133 × 102 cm
(52½ × 40¼ inches)
PAGE 81

The Sound of Music 1995–2007
Oil paint on table
76 × 90 × 80 cm
(30 × 35½ × 31½ inches)
PAGE 83

*Some Velvet Morning When I'm Straight
I'm Going to Open Your Gates* 2007
Oil on panel
222 × 146 cm
(87½ × 58¼ inches)
PAGE 85

Deep Throat 2007
Oil on panel
152 × 122 cm
(59¾ × 48 inches)
PAGE 87

The Alabama Song 2007
Oil on panel
146 × 120 cm
(57½ × 47¼ inches)
PAGE 91

Senile Youth 2007
Oil on panel
122 × 156 cm
(48 × 61½ inches)
PAGES 93–94

Life Is Empty and Meaningless 2005
Oil paint on acrylic medium and plaster
on metal armature
82.5 × 76 × 43 cm
(32½ × 30 × 17 inches)
PAGE 97

Polichinelle 2007
Oil on panel
130 × 106 cm
(51¼ × 41¾ inches)
PAGE 99

Tart Wit, Wise Humor 2007
Oil on panel
144 × 108.5 cm
(56¾ × 42¼ inches)
PAGE 101

America 2004
Oil on panel
140 × 93 cm
(55 × 36½ inches)
PAGE 113

Architecture and Morality 2004
Oil on panel
140 × 98 cm
(55 × 38½ inches)
PAGE 115

Death Disco 2004
Oil on panel
134 × 89 cm
(52¾ × 35 inches)
PAGE 117

Dirty 2003
Oil on panel
105 × 83 cm
(41¼ × 32¾ inches)
PAGE 121

Alas Dies Laughing 2004
Oil paint on acrylic medium and plaster
on metal armature
60 × 75 × 46 cm
(23¾ × 29½ × 18¼ inches)
PAGES 122–23

Filth 2004
Oil on panel
133 × 94 cm
(52½ × 37 inches)
PAGE 125

Sex 2003
Oil on panel
126 × 85 cm
(49¾ × 33½ inches)
PAGE 127

Three Wise Virgins 2004
Oil paint on acrylic medium and plaster
on metal armature
85 × 55 × 55 cm
(33½ × 21¾ × 21¾ inches)
PAGES 128–29

The Osmond Family 2003
Oil on panel
142.5 × 100.5 cm
(56¼ × 39½ inches)
PAGE 131

Biography

Born 1966,
Hexham, Northumberland, England.
Lives and works in London.

EDUCATION

1992
Goldsmiths College, University of London,
London.

1988
Bath College of Higher Education, Bath,
England.

1985
Norwich School of Art, Foundation
Course, Norwich, England.

SELECTED SOLO EXHIBITIONS

2009
Gagosian Gallery, London.*
Glenn Brown: Etchings (Portraits),
Ridinghouse at Karsten Schubert,
London.*
Tate Liverpool, Liverpool. Travelled to:
Fondazione Sandretto Re Rebaudengo,
Turin.*

2008
*Glenn Brown: Editions and a Unique
Sculpture*, Patrick Painter, Los Angeles.
Kunsthistorisches Museum, Vienna.*

2007
Gagosian Gallery, New York.*

2006
Galerie Max Hetzler, Berlin.*

2005
Patrick Painter, Los Angeles.

2004
Serpentine Gallery, London.*
Gagosian Gallery, New York.*

2002
Galerie Max Hetzler, Berlin.

2001
Patrick Painter, Los Angeles.

2000
Domaine de Kerguéhennec, Centre d'Art
Contemporain, Bignan, France.*
Galerie Max Hetzler, Berlin.

1999
Patrick Painter, Los Angeles.
Jerwood Gallery, London.*

1998
Patrick Painter, Los Angeles.

1997
Galerie Ghislaine Hussenot, Paris.

1996
Queen's Hall Arts Centre, Hexham,
England.*

1995
Karsten Schubert, London.*

SELECTED GROUP EXHIBITIONS

2009
Art Now: Beating The Bounds, Tate Britain,
London.
*Mapping the Studio: Artists from the François
Pinault Collection*, Punta della Dogana
and Palazzo Grassi, Venice.*
Surface Reality, Laing Art Gallery, Tyne and
Wear Museums, Newcastle upon Tyne,
England.

2008
Beyond the Lens, Galerie Dominique Fiat,
Paris.
*Excerpt: Selections from the Jeanne Greenberg
Rohatyn Collection* (curated by Richard B.
Fisher), Frances Lehman Loeb Art
Center, Vassar College, Poughkeepsie,
USA.*
Arcadia: Painters' Paradise, Seoul Museum
of Art, Seoul. Travelled to: Taipei Fine
Arts Museum, Taipei, as *Arcadie: Dans les
collections du Centre Pompidou*.*
Pretty Ugly (curated by Alison Gingeras),
Gavin Brown's Enterprise and
Maccarone, New York.
Jekyll Island (curated by Erik Parker and

Max Henry), Honor Fraser Gallery,
Los Angeles.

2007
Attention to Detail (curated by Chuck
Close), The FLAG Art Foundation,
New York.
Insight?, Gagosian Gallery, Barvikha
Luxury Village, Moscow.*
*Der Symbolismus und die Kunst der
Gegenwart*, Von der Heydt-Museum,
Wuppertal, Germany.*
Rockers Island: Olbricht Collection, Museum
Folkwang, Essen, Germany.*
Old School, Hauser and Wirth Colnaghi,
London.*
100 Jahre Kunsthalle Mannheim, Kunsthalle
Mannheim, Mannheim, Germany.
Accidental Painting, Perry Rubenstein
Gallery, New York.
*Timer 01: Intimità/Intimacy, L'arte
contemporanea dopo l'undici settembre/
Contemporary Art After Nine Eleven*,
Triennale Bovisa, Milan.*
Photopeintres, FRAC Limousin, Limoges,
France.

2006
*Jean-Honoré Fragonard, 1732–1806: Orígenes
e influencias, de Rembrandt al siglo XXI*,
Obra Social Fundación "la Caixa",
Barcelona.*
*How to Improve the World: Sixty Years of
British Art*, Arts Council Collection,
Hayward Gallery, London.*
*The Starry Messenger: Visions of the
Universe*, Compton Verney,
Warwickshire, England.*
Zurück zur Figur: Malerei der Gegenwart,
Kunsthalle der Hypo-Kulturstiftung,
Munich. Travelled to: Museum Franz
Gertsch, Burgdorf, Switzerland.*
British Art, Thomas Gibson Fine Art,
London.*
*Infinite Painting: Contemporary Painting and
Global Realism*, Villa Manin, Centro

d'Arte Contemporanea, Udine, Italy.*

Passion for Paint, Bristol City Museum and Art Gallery, Bristol, England. Travelled to: Laing Art Gallery, Tyne and Wear Museums, Newcastle upon Tyne, England; The National Gallery, London.*

Full House: Gesichter einer Sammlung, Kunsthalle Mannheim, Mannheim, Germany.

POW! (Pictures of Women), Quality Pictures Contemporary Art, Portland, Oregon, USA.

Chers amis, Domaine de Kerguéhennec, Centre d'Art Contemporain, Bignan, France.

2005

Neue Kunsthalle IV: Direkte Malerei/Direct Painting, Kunsthalle Mannheim, Mannheim, Germany.*

Ecstasy: In and About Altered States, The Geffen Contemporary, Museum of Contemporary Art, Los Angeles.*

Rückkehr ins All/Return to Space, Hamburger Kunsthalle, Hamburg.*

Closing Down, Bortolami Dayan, New York.

Big Bang: Destruction et création dans l'art du XXe siècle, Centre Georges Pompidou, Paris.*

Translations: Creative Copying and Originality (curated by Karsten Schubert), Thomas Dane, London.

The Nature of Things, Birmingham Museum and Art Gallery, Birmingham, England.

STRATA: Difference and Repetition, Fondazione Davide Halevim, Milan.

Bidibidobidiboo: Works from Collezione Sandretto Re Rebaudengo (curated by Francesco Bonami), Fondazione Sandretto Re Rebaudengo, Turin.*

2004

Must I Paint You a Picture? Six London-Based Artists, Haunch of Venison, London.

PILLish: Harsh Realities and Gorgeous Destinations, Museum of Contemporary Art, Denver, USA.

She's Come Undone, Artemis Greenberg Van Doren Gallery, New York.

Painter Editions, Patrick Painter, Los Angeles.

2003

Heißkalt: Aktuelle Malerei aus der Sammlung Scharpff, Staatsgalerie Stuttgart, Stuttgart. Travelled to: Hamburger Kunsthalle, Hamburg.*

Breaking God's Heart (curated by Glenn Brown), 38 Langham Street, London.

Dreams and Conflicts: The Dictatorship of the Viewer, part of *La Biennale di Venezia*, Padiglione Italia, Giardini della Biennale, Venice.*

Pittura/Painting: From Rauschenberg to Murakami, 1964–2003, Museo Correr, Venice.*

Une collection de "chefs-d'œuvre", FRAC Limousin, Limoges, France.*

M_ARS: Kunst und Krieg, Neue Galerie am Landesmuseum Joanneum, Graz, Austria.*

2002

Cher Peintre: Peintures figuratives depuis l'ultime Picabia, Centre Georges Pompidou, Paris. Travelled to: Kunsthalle Wien, Vienna; Schirn Kunsthalle Frankfurt, Frankfurt.*

Melodrama, Artium, Centro-Museo Vasco de Arte Contemporaneo, Vitoria-Gasteiz, Spain. Travelled to: Palacio de los Condes de Gabia, Granada, Spain; Museo de Arte Contemporanea de Vigo, Vigo, Spain.*

Landscape, The Saatchi Gallery, London.*

(The World May Be) Fantastic: 2002 Biennale of Sydney, Museum of Contemporary Art, Sydney, and Art Gallery of New South Wales, Sydney.*

XXV Bienal de São Paulo: Iconografias metropolitanas, Pavilhão Ciccillio Matarazzo, Parque do Ibirapuera, São Paulo, Brazil.*

Painting as a Foreign Language, Centro Brasileiro Britânico, São Paulo, Brazil.*

From the Saatchi Gift, Talbot Rice Gallery, The University of Edinburgh, Edinburgh.

2001

Passion, Galerie Ascan Crone, Berlin and Hamburg.

AZERTY: Un abécédaire autour des collections du FRAC Limousin, Centre Georges Pompidou, Paris.*

Glenn Brown and Arnold Böcklin, Künstlerverein Malkasten, Düsseldorf.

2000

Salon, Delfina Studio Trust, London.

Hypermental: Rampant Reality 1950–2000, from Salvador Dalí to Jeff Koons, Kunsthaus Zürich, Zurich. Travelled to: Hamburger Kunsthalle, Hamburg; Rudolfinum, Prague.*

The Turner Prize 2000, Tate Britain, London.*

Little Angels, Houldsworth Gallery, London.*

Suite Substitute IV: Beautiful Strangers, Hôtel du Rhone, Geneva.

Futuro: Decadent Art and Architecture, Center for Visual Arts, Cardiff, Wales.

The British Art Show 5, organised by Hayward Gallery, London, for the Arts Council of England. Travelled to: Scottish Gallery of Modern Art, Edinburgh; John Hansard Gallery, The Southampton Art Gallery, and Millais Gallery, Southampton, England; National Museum of Wales, Cardiff, Wales; Birmingham Museum and Contemporary Art Gallery, Birmingham, England.*

Glenn Brown, Julie Mehretu, Peter Rostovsky, The Project, New York.

The Wreck of Hope, The Nunnery Gallery, Bow Arts Trust, London.

Blue: Borrowed and New, New Art Gallery Walsall, Walsall, England.*

Sausages and Frankfurters: Recent British and German Paintings from the Ophiuchus Collection, The Hydra Workshop, Hydra, Greece.*

1999

Disaster, Harris Museum and Art Gallery, Preston, England.

Day of the Donkey Day, Transmission Gallery, Glasgow.

John Moores 21, Walker Art Gallery, Liverpool, England.*

Fresh Paint: Recent Acquisitions from the Frank Cohen Collection, Gallery of Modern Art, Glasgow.

Examining Pictures: Exhibiting Paintings, Whitechapel Art Gallery, London.

Travelled to: Museum of Contemporary Art, Chicago; The Armand Hammer Museum of Art and Cultural Center, University of California, Los Angeles.*
Holding Court, Entwistle Gallery, London.

1998
Secret Victorians: Contemporary Artists and a Nineteenth-Century Vision, Firstsite at the Minorities Art Gallery, Colchester, England. Travelled to: Arnolfini, Bristol, England; Ikon Gallery, Birmingham, England; Middlesbrough Art Gallery, Middlesbrough, England; and The Armand Hammer Museum of Art and Cultural Center, University of California, Los Angeles.*
Abstract Painting, Once Removed: A Fiftieth Anniversary Exhibition, Contemporary Arts Museum, Houston, USA. Travelled to: Kemper Museum of Contemporary Art, Kansas City, USA.*
It's a Curse, It's a Burden (curated by Glenn Brown), The Approach, London.
Cluster Bomb, Morrison Judd, London.
New Works, Patrick Painter, Los Angeles.

1997
Sensation: Young British Artists from the Saatchi Collection, Royal Academy of Arts, London. Travelled to: Hamburger Bahnhof, Berlin; Brooklyn Museum, New York.*
Pure Fantasy, Oriel Mostyn Gallery, Llandudno, Wales.*
Treasure Island/A ilha do tesouro, Fundação Calouste Gulbenkian, Centro de Arte Moderna, José de Azeredo Perdigão, Lisbon.*
Belladonna, Institute of Contemporary Arts, London.
Glenn Brown, Alex Katz, Katherine Yass, Galerie Barbara Thumm, Berlin.

1996
Glenn Brown, Peter Doig, Jim Hodges, Adriana Varejao, Galerie Ghislaine Hussenot, Paris.
Twenty-one Days of Darkness, Transmission Gallery, Glasgow.
ACE: Arts Council Collection New Purchases, Hatton Gallery, Newcastle

University, Newcastle upon Tyne, England. Travelled to: Harris Museum and Art Gallery, Preston, England; Gallery Oldham, Oldham, England; Hayward Gallery, London; Ikon Gallery, Birmingham, England; Mappin Art Gallery, Sheffield, England; Angel Row Gallery, Nottingham, England; Ormeau Baths Gallery, Belfast.
Out of Space, Cole and Cole, Oxford.
StrangeDays, The Agency Gallery, London.
The Jerwood Painting Prize, Lethaby Gallery, Central Saint Martins College, London.
Fernbedienung: Does Television Inform the Way Art Is Made?, Grazer Kunstverein, Graz, Austria.*
About Vision: New British Painting in the 1990s, Museum of Modern Art, Oxford.*

1995
Brilliant! New Art from London, Walker Art Center, Minneapolis, USA. Travelled to: Contemporary Arts Museum, Houston, USA.*
From Here, Waddington Galleries, London, and Karsten Schubert, London.*
Summer Group Show, Karsten Schubert, London.
Young British Artists V, The Saatchi Gallery, London.*
Obsession, The Tannery, London.
Painters' Opinion, Bloom Gallery, Amsterdam.
That's Not the Way to Do It, Project Space, University of Northumbria at Newcastle, Newcastle upon Tyne, England.

1994
Here and Now, Serpentine Gallery, London.
Every Now and Then, Rear Window at Richard Salmon, London.

1993
Painting Invitational, Barbara Gladstone Gallery, New York.
Re-Present, Todd Gallery, London.
Launch, Curtain Road Arts, London.
Barclays Young Artists Award, Serpentine Gallery, London.*
Mandy Loves Declan 100%, Mark Boote Gallery, New York.*

1992
Surface Values, Kettle's Yard, Cambridge, England.
How Did These Children Come to Be Like That, Goldsmiths Gallery, London.
With Attitude, Galerie Guy Ledune, Brussels.
And What Do You Represent?, Anthony Reynolds Gallery, London.

1991
Group Show, Todd Gallery, London.

1990
British Telecom New Contemporaries 1990, Arnolfini, Bristol, England. Travelled to: John Hansard Gallery, Southampton, England; Dean Clough, Halifax, England; Ikon Gallery, Birmingham, England; Arts Council Gallery, Belfast; Third Eye Centre, Glasgow; Institute of Contemporary Arts, London.*

1989
Christie's New Contemporaries, The Royal College of Art, London.*
British Telecom New Contemporaries 1989, Institute of Contemporary Arts, London. Travelled to: Cornerhouse, Manchester, England; South Hill Park, Bracknell, England; Dean Clough, Halifax, England; Brewery Arts Centre, Kendal, England.*

AWARDS

Shortlist, South Bank Show Awards, 2005.
Shortlist, Turner Prize, Tate Britain, London, 2000.

* Indicates exhibition publication

Bibliography

MONOGRAPHS

2009

Glenn Brown. London: Tate. Edited by Francesco Bonami and Christoph Grunenberg; texts by Lawrence Sillars and Michael Stubbs.

Glenn Brown: Etchings (Portraits). London: Ridinghouse. Text by John-Paul Stonnard.

2008

Glenn Brown. Vienna: Kunsthistorisches Museum. Interview by Katarzyna Uszynska.

2007

Glenn Brown. New York: Gagosian Gallery. Text by Michael Bracewell.

2006

Glenn Brown. Berlin: Galerie Max Hetzler and Holzwarth Publications. Text by Tom Morton.

2004

Glenn Brown. London: Serpentine Gallery. Text by Alison M. Gingeras; interview by Rochelle Steiner.

Glenn Brown. New York: Gagosian Gallery. Text by David Freedberg.

2000

Glenn Brown. Bignan, France: Domaine de Kerguéhennec, Centre d'Art Contemporain. Texts by Terry R. Myers and Frédéric Paul; interview by Stephen Hepworth.

1999

Glenn Brown. London: Jerwood Gallery. Text by Ian Hunt.

1996

Glenn Brown. Hexham, England: Queen's Hall Arts Centre; London: Karsten Schubert. Text by Phil King; interview by Marcelo Spinelli.

GROUP CATALOGUES AND BOOKS

2009

Arcadie: Dans les collections du Centre Pompidou. Taipei: Taipei Fine Arts Museum. Edited by Didier Ottinger.

Mapping the Studio: Artists from the François Pinault Collection. Milan: Electa. Edited by Francesco Bonami and Alison M. Gingeras.

2008

Art Now, Volume III. Cologne: Taschen. Edited by Hans Werner Holzwarth.

Cranford Collection 01. London: Cranford Collection. Text by Andrew Renton.

Excerpt: Selections from the Jeanne Greenberg Rohatyn Collection. Poughkeepsie, USA: Frances Lehman Loeb Art Center, Vassar College.

Heiser, Jorg. *All of a Sudden: Things that Matter in Contemporary Art*. Berlin: Sternberg Press.

2007

Button, Virginia. *The Turner Prize: Revised Edition*. London: Tate.

Cuzin, Jean-Pierre, and Dimitri Salmon. *Fragonard Regards/Croisés*. Paris: Mengés.

Insight?. New York: Gagosian Gallery.

Old School. London: Hauser and Wirth Colnaghi. Text by Gregor Muir.

Rockers Island: Olbricht Collection. Essen, Germany: Museum Folkwang; Göttingen, Germany: Steidl.

Der Symbolismus und die Kunst der Gegenwart. Wuppertal, Germany: Von der Heydt-Museum. Texts by Alexandra Bruchmann, Gerhard Finckh, Ann-Katrin Günzel, Hans Hofstätter, Tobias Janz, Franz Nagel, and Ute Riese.

Timer 01: Intimità/Intimacy, L'arte contemporanea dopo l'undici settembre/ Contemporary Art After Nine Eleven. Milan: Skira-Berenice. Edited by Gianni Mercurio and Demetrio Paparoni.

2006

British Art. London: Thomas Gibson Fine Art.

How to Improve the World: Sixty Years of British Art, Arts Council Collection. London: Hayward Gallery. Texts by Marjorie Althorpe-Guyton, Michael Archer, and Roger Malbert.

Infinite Painting: Contemporary Painting and Global Realism. Udine, Italy: Villa Manin, Centro d'Arte Contemporanea.

Jean-Honoré Fragonard, 1732–1806: Orígenes e influencias, de Rembrandt al siglo XXI. Barcelona: Obra Social Fundación "la Caixa". Text by Katharina Schmidt.

Lindemann, Adam. *Collecting Contemporary Art*. Cologne: Taschen.

Mullins, Charlotte. *Painting People: The State of the Art*. London: Thames and Hudson.

Passion for Paint. London: National Gallery. Text by Sarah Richardson.

The Starry Messenger: Visions of the Universe: Warwickshire, England: Compton Verney.

Zurück zur Figur: Malerei der Gegenwart. Munich: Kunsthalle der Hypo-Kulturstiftung and Prestel.

2005

Art Now, Volume II. Cologne: Taschen. Edited by Uta Grosenick; text by Ossian Ward.

Bidibidobidiboo: Works from Collezione Sandretto Re Rebaudengo. Turin: Fondazione Sandretto Re Rebaudengo. Text by Francesco Bonami.

Big Bang: Creation and Destruction in Twentieth Century Art. Paris: Éditions du Centre Georges Pompidou. Edited by Catherine Grenier; text by Agnès de la Baumelle.

Bits and Pieces Put Together to Present a Semblance of a Whole. Minneapolis,

USA: Walker Art Center. Edited by
Joan Rothfuss and Elizabeth Carpenter.

Ecstasy: In and About Altered States. Los
Angeles: Museum of Contemporary Art;
Cambridge, USA: MIT Press. Edited by
Lisa Mark; text by Paul Schimmel.

Neue Kunsthalle IV: Direct Painting.
Hamburg: Hamburger Kunsthalle;
Ostfildern-Ruit, Germany: Hatje Cantz.
Edited by Christoph Heinrich.

Rückkehr ins All/Return to Space. Hamburg:
Hamburger Kunsthalle; Ostfildern-Ruit,
Germany: Hatje Cantz. Edited by
Christoph Heinrich; text by Markus
Heinzelmann.

2004

Berlin 1994–2003. Berlin: Galerie Max
Hetzler. Text by Frédéric Paul.

*Ice Hot: Recent Painting from the Scharpff
Collection*. Hamburg: Hamburger
Kunsthalle; Stuttgart: Staatsgalerie
Stuttgart. Texts by Marvin Altner and
Christoph Heinrich.

2003

100: The Work that Changed British Art.
London: Jonathan Cape and Saatchi
Gallery. Text by Patricia Ellis.

Button, Virginia. *The Turner Prize: Twenty
Years*. London: Tate.

Une collection de "chefs-d'œuvre". Limoges,
France: FRAC Limousin.

Cork, Richard. *Breaking Down the Barriers:
Art in the 1990s*. New Haven, USA:
Yale University Press.

*Dreams and Conflicts: The Dictatorship of the
Viewer. La Biennale di Venezia, Fiftieth
International Art Exhibition*. Venice:
Marsilio. Edited by Francesco Bonami
and Maria Luisa Frisa.

M_ARS: Kunst und Krieg. Graz, Austria:
Neue Galerie am Landesmuseum
Joanneum; Ostfildern-Ruit, Germany:
Hatje Cantz. Edited by Peter Weibel.

*Pittura/Painting: From Rauschenberg to
Murakami, 1964–2003*. Venice: Museo
Correr.

Vitamin P: New Perspectives in Painting.
London: Phaidon. Text by Barry
Schwabsky.

2002

*XXV Bienal de São Paulo: Iconografias
metropolitanas*. São Paulo, Brazil:
Fundação Bienal de São Paulo.

*Art Now: 137 Artists at the Rise of the New
Millennium*. Cologne: Taschen. Edited
by Uta Grosenick and Burkhard
Riemschneider; text on Glenn Brown
by Frank Frangenberg.

*"Dear Painter, Paint Me . . . ": Painting the
Figure since Late Picabia*. Paris: Éditions
du Centre Georges Pompidou; Vienna:
Kunsthalle Wien; Frankfurt: Schirn
Kunsthalle Frankfurt. Edited by
Alison M. Gingeras; texts on Glenn
Brown by Sabine Folie and Gemima
Montagu.

Landscape. London: Saatchi Gallery.

McLean, Daniel, and Karsten Schubert.
Dear Images: Art, Copyright, and Culture.
London: Ridinghouse, Institute of
Contemporary Art.

Melodrama. Vitoria-Gasteiz, Spain:
Artium, Centro-Museo Vasco de Arte
Contemporaneo; Granada, Spain: Palacio
de los Condes de Gabia; Vigo, Spain:
Museo de Arte Contemporanea de Vigo.
Edited by Doreet LeVitte Harten; text
by Juan Miguel Company-Ramón.

Painting as a Foreign Language. São Paulo,
Brazil: Cultura Inglesa, Centro Brasileiro
Britânico. Text by Suhail Malik.

*(The World May Be) Fantastic: 2002 Biennale
of Sydney*. Sydney: Museum of Contem-
porary Art. Text by Richard Grayson.

2001

*AZERTY: Un abécédaire autour des
collections du FRAC Limousin*. Paris:
Éditions du Centre Georges Pompidou.
Text by Alison M. Gingeras.

*Frank Auerbach: Painting and Drawings,
1954–2001*. London: Royal Academy of
Arts. Text by Catherine Lampert.

2000

Blue: Borrowed and New. Walsall, England:
New Art Gallery Walsall. Edited by John
Gage and Mike Tobey.

The British Art Show 5. London: South
Bank Centre. Texts by Tony Godfrey,
Matthew Higgs, Helen Luckett, and
Marcelo Spinelli.

*Hypermental: Rampant Reality 1950–2000,
from Salvador Dalí to Jeff Koons*. Zurich:
Kunsthaus Zürich; Hamburg: Hamburger
Kunsthalle; Ostfildern-Ruit, Germany:
Hatje Cantz. Texts by Sibylle Berg,
Norman Bryson, Bice Curiger, Paul D.
Miller, Griselda Pollock, Gero von
Randow, and Peter Weibel.

Little Angels. London: Houldsworth
Gallery. Text by Christopher Bucklow.

*The Saatchi Gift to the Arts Council
Collection*. London: Hayward Gallery.
Text by Isabel Johnstone.

*Sausages and Frankfurters: Recent British
and German Paintings from the Ophiuchus
Collection*. Hydra, Greece: Hydra
Workshop.

The Turner Prize 2000. London: Tate Britain.
Text by Mary Horlock.

1999

Collings, Matthew. *This Is Modern Art*.
London: Weidenfeld and Nicolson.

Examining Pictures: Exhibiting Paintings.
London: Whitechapel Art Gallery;
Chicago: Museum of Contemporary Art.
Texts by Robert Fitzpatrick and
Catherine Lampert.

John Moores 21. Liverpool, England: Walker
Art Gallery. Text by Richard Cork.

Stallabrass, Julian. *High Art Lite*. London:
Verso.

1998

Abstract Painting, Once Removed. Houston,
USA: Contemporary Arts Museum. Texts
by Dana Friis-Hansen, David Pagel,
Raphael Rubinstein, and Peter Schjeldahl.

Ferry, Luc. *Le sens du beau*. Paris: Éditions
Cercle d'Art.

*Secret Victorians: Contemporary Artists
and a Nineteenth-Century Vision*. London:
Hayward Gallery. Texts by Melissa
Feldman and Ingrid Schaffner.

1997

Collings, Matthew. *Blimey! From Bohemia
to Britpop*. Cambridge, England:
21 Publishing.

Pure Fantasy. Llandudno, Wales: Oriel
Mostyn Gallery. Text by Susan Daniel.

*Sensation: Young British Artists from the
Saatchi Collection*. London: Royal

Academy of Arts and Thames and
Hudson. Texts by Brooks Adams, David
Barrett, Lisa Jardine, Martin Maloney,
Norman Rosenthal, and Richard Shone.
Treasure Island/A ilha do tesouro. Lisbon:
Fundação Calouste Gulbenkian, Centro
de Arte Moderna, José de Azeredo
Perdigão. Texts by Jorge Molder and
Rui Sanches.

1996
*About Vision: New British Painting in the
1990s*. Oxford: Museum of Modern Art.
Text by David Elliott.
*Fernbedienung: Does Television Inform the
Way Art Is Made?*. Graz, Austria: Grazer
Kunstverein. Texts by Klemens Gruber,
Lynne Joyrich, Theo Ligthart, Jeff Rian,
Johann Skocek, Eva Maria Stadler, and
Thomas Trummer.
Lucie-Smith, Edward. *Visual Arts in
the Twentieth Century*. London:
Lawrence King.

1995
Brilliant! New Art from London. Minneapolis,
USA: Walker Art Center. Texts by
Richard Flood, Douglas Fogle, Stuart
Morgan, and Neville Wakefield; inter-
views by Douglas Fogle and Marcelo
Spinelli.
From Here. London: Waddington Galleries
and Karsten Schubert. Text by Andrew
Wilson.
*Shark Infested Waters: The Saatchi Collection
of British Art in the 90s*. London:
Zwemmer. Text by Sarah Kent.
Young British Artists V. London: Saatchi
Gallery. Text by Sarah Kent.

1993
Barclays Young Artist Award. London:
Serpentine Gallery. Text by Sarah Kent.
Mandy Loves Declan 100%. New York: Mark
Boote Gallery. Text by Stuart Morgan.

1990
British Telecom New Contemporaries 1990.
Bristol, England: New Contemporaries.
Texts by Marianne Brouwer, Franz
Kaiser, and Alistair McLennan.

1989
British Telecom New Contemporaries 1989.
London: New Contemporaries. Text by
Sacha Craddock.
Christie's New Contemporaries. London:
Royal College of Art.

ARTICLES AND REVIEWS

2009
Anderson, Vicky. "Taking a Fresh Look at
Art." *Daily Post*, February 6, pp. 4–5.
Brown, Christopher. "Glenn Brown's
Unusual Obsessions." *Metro*, February
20, Life, p. 25.
Brown, Jonathan. "A Real Scene Stealer."
The Independent (London), February 16,
pp. 14–15.
Darwent, Charles. "The Fine Art of
Copycatting." *The Independent on Sunday*
(London), January 25, pp. 64–65.
Gingeras, Alison M., and Rochelle Steiner.
"A Careful Concoction of 'Push' and
'Pull'." *Tate etc.*, Spring, pp. 38–47.
Herbert, Martin. "Glenn Brown." *Frieze*,
no. 124 (June/July/August), p. 186.
Januszczak, Waldemar. "The Thinking
Man's Painter." *The Times* (London),
March 22, pp. 18–19.
Jones, Catherine. "Review: Glenn Brown
Retrospective." *Liverpool Echo*,
February 25, p. 27.
Kent, Sarah. "Putrid Beauty." *Modern
Painters* 21, no. 4 (May), pp. 34–36.
Lubbock, Tom. "Highlights of 2009: Art."
The Independent (London), January 2, p. 9.
MacRitchie, Lynn. "Glenn Brown, an
Interview." *Art in America* 97, no. 4
(April), pp. 90–101.
Robinson, Walter. "Glenn Brown
Retrospective." *Artnet.com*, February 12.
Rose, Rebecca. "Devil in the Detail."
Financial Times (London), February 28.
"Themen: Malerei." *ART: Das Kunst-
magazin* (Hamburg), no. 15 (July).
Trigg, David. "Painting Paintings: Glenn
Brown Interviewed." *Art Monthly*
(London), no. 325 (April), pp. 1–4.
Wright, Karen. "Glenn Brown—Simply
a Great Artist." *Phillipsartexpert.com*
and *The Independent* (London),
February 23.

2008
Fishof, Ohad. "Correlation of Desires: An
Interview with Doreet LeVitte Harten."
Studio: Israeli Art Magazine, January–
February, pp. 40–48.

2007
Alpers, Svetlana, and Matthew Collings.
"The Painter: Fictions of the Studio, the
Shadows of the Photographic, and
Contemporary Ghosts of Empathy."
Modern Painters 75 (February), pp. 76–83.
Campbell-Johnson, Rachel. "Old Masters,
Young Pretenders." *The Times* (London),
May 8, p. 14.
Kalhama, Pilvi. "Medioista maalaukseen."
Taide (Helsinki), January, pp. 38–43.
"Preview: Es wird verdammt symbolisch in
Wuppertal." *Monopol*, June, p. 108.

2006
Grant, Daniel. "Collecting Advice."
Art News 105, no. 8 (September), p. 100.
Wittneven, Katrin. "Frankensteins Sohn."
Der Tagesspiegel (Berlin), February 18.

2005
Bishop, Claire. "But Is It—Installation
Art?" *Tate etc.*, Spring, pp. 26–35.
Coomer, Martin. "Review: Glenn Brown
at Haunch of Venison." *Time Out*
(London), January 12, p. 58.
Gleadell, Colin. "Painting by Numbers."
ArtReview, April, pp. 47–48.
Heiser, Jörg. "Master and Minion." *Parkett*,
no. 75, pp. 133–39.
Higgie, Jennifer. "He Paints Paint." *Parkett*,
no. 75, pp. 106–09.
———. "London Hits the $100 Million
Mark." *Art Monthly* (London), no. 285
(April 5), pp. 38–39.
Myers, Terry R. "Coming Up Roses."
ArtReview, June/July, pp. 38–40.
Smith, Trevor. "The Fantastic Voyage of
Glenn Brown." *Parkett*, no. 75, pp. 116–21.

2004
Brown, Glenn. "Questionnaire: Glenn
Brown." *Frieze*, no. 85 (September), p. 132.
Burnett, Craig. "Glenn Brown: The Divine
and the Dirty." *Contemporary* (London),
no. 66 (October), pp. 37–42.

Charlesworth, J. J. "Fever." *Flash Art*, no. 239 (November/December), pp. 84–87.

Collings, Matthew. "Diary: Getting Ahead in New York." *Modern Painters* 17, no. 2 (Summer), pp. 18–23.

Cumming, Laura. "To Make Your City, First Take an Egg." *Review*, supplement to *The Observer* (London), September 19, p. 10.

Darwent, Charles. "Homage or Vampirism? No Contest." *The Independent on Sunday* (London), September 19, p. 25.

Dormant, Richard. "A Magritte for Our Age." *The Daily Telegraph* (London), September 22, p. 21.

Ebony, David. "First Night: Lost in Space with a Master of Illusionist Art." *The Times* (London), September 16.

———. "Review: Glenn Brown at Gagosian." *Art in America* 92, no. 9 (October), p. 156.

Goodbody, Bridget L. "Glenn Brown, Gagosian Gallery." *Time Out* (New York), April 1, p. 60.

Guner, Fisun. "Copy and Pastiche." *The Times* (London), September 20.

Hackworth, Nick. "Dr. Frankenstein's Pick-and-Mix Show." *Evening Standard* (London), September 14, p. 63.

Herbert, Martin. "Preview: Glenn Brown at Serpentine Gallery." *Artforum* 63, no. 1 (September), p. 113.

Januszczak, Waldemar. "Look Here—Brit Art Has Entered a Brave New World." *Culture Magazine*, supplement to *The Sunday Times* (London), September 19, p. 11.

Johnston, Rachel Campbell. "Passion of an Illusionist Who Leaves Us Lost in Space." *The Times* (London), September 15, p. 10.

———. "Sci-Fi Deceptions that Seduce." *The Times* (London), September 15, p. 9.

Kent, Sarah. "Altered States." *Time Out* (London), September 22, p. 60.

Laguente, Pablo. "Glenn Brown: Classic Contemporary." *Flash Art*, no. 236 (May/June), pp. 110–12.

L. B., "Verbatim: Glenn Brown." *The Art Newspaper* (London), no. 151 (September), pp. 110–12.

Lillington, David. "Kopiist Voor Het Leven: Notities bij een gesprek met Glenn Brown." *Metropolis M* (Utrecht, Netherlands), no. 6 (December/January), pp. 101–13.

Lubbock, Tom. "Brushing Up on the Cliches." *The Independent* (London), September 21, pp. 12–13.

Macmillan, Ian. "You Take My Place in This Showdown." *Modern Painters* 17, no. 3 (Autumn), pp. 78–81.

Martin, Esmeralda. "Glenn Brown: Do Artists Dream of Electric Landscapes?" *Belio* (Madrid), no. 13, pp. 31–36.

"Modern Classic." *ArtReview*, March, p. 22.

Packer, William. "Glenn Brown, Serpentine Gallery, London." *Financial Times Europe* (London), September 23, p. 15.

Prince, Mark. "Pop Art." *Art Monthly* (London), no. 276 (May), pp. 6–9.

Rodriguez, Edel. "Glenn Brown at Gagosian." *The New Yorker*, March 29, pp. 16–17.

Vallese, Gloria. "Glenn Brown, Nato per spiazzare." *Arte* (Rome), no. 374, pp. 126–30.

Wilsher, Mark. "Judgement Call." *Art Monthly* (London), no. 280 (October), pp. 7–10.

Wilson, Michael. "Review: Glenn Brown at Gagosian Gallery." *Artforum* 42, no. 10 (Summer), p. 246.

2003

Adams, Brooks. "Picabia: The New Paradigm." *Art in America* 91, no. 3 (March), pp. 84–91.

Asmus, Dieter. "Heiliger auf Umlaufbahn." *Kunstzeitung*, no. 82 (June), p. 25.

La Placa, Joe, and Walter Robinson. "New London Sun." *Artnet Magazine*, October.

Nochlin, Linda. "New Tricks for an Old Dog: The Return of Painting." *Contemporary* (London), no. 38, pp. 18–23.

2002

Bracewell, Michael. "History for Pissing On." *Tate Magazine*, no. 29 (Summer), pp. 34–39.

Bush, Kate. "Cher Peintre, Lieber Maler, Dear Painter." *Artforum* 41, no. 2 (October), p. 148.

Dent, Nick. "Copy Boy." *Black and White* (London), no. 61 (June/July), p. 18.

Edwards, Natasha. "Cher Peintre Peins-Moi!" *Modern Painters* 15, no. 3 (Autumn), p. 145.

Foster, Stephen. "Painting as a Foreign Language," *Contemporary* (London), special issue, June/July/August, pp. 148–49.

Gute, Charles, Peter Herbstreuth, Samuele Menin, and Michele Robecchi. "Focus Painting, Part One." *Flash Art*, no. 226 (October), p. 80.

Muchnic, Suzanne. "Glenn Brown: Patrick Painter." *Art News* 101, no. 1 (January), p. 125.

Tufnell, Ben. "Dear Painter, Paint Me: Painting the Figure since Late Picabia." *Contemporary* (London), no. 43 (September), pp. 90–91.

2001

Feaver, William. "Turner Prize 2000." *Art News* 100, no. 2 (February), p. 65.

Lydiate, Henry. "Copyright: Originality." *Art Monthly* (London), no. 243 (February), pp. 52–53.

2000

Alberge, Dalya, and Ian Cobain. "Copycat Row as *The Times* Reveals Turner Prize Artist's Inspiration." *The Times* (London), November 28, pp. 1, 3.

Cobain, Ian. "Portrait of an Artist Caught in a Pretty Bad Light." *The Times* (London), November 29, p. 3.

Cork, Richard. "Dazzling Spectacle and in No Sense a Rip-Off." *The Times* (London), November 28, p. 3.

———. "Farewell Then, Britart." *The Times* (London), October 25, Arts, pp. 20–21.

Dorment, Richard. "Turner Prize: No Sheep, No Beds, No Dung—Just Fine Art." *The Daily Telegraph* (London), October 25, p. 23.

Gibb, Francis. "Lawyers Advise on a Claim for Compensation." *The Times* (London), November 29, p. 3.

Grant, Simon. "Turner Prize." *Tate Magazine*, no. 23 (Winter), p. 90.

Herbstreuth, Peter. "Glenn Brown: Max Hetzler." *Flash Art*, no. 215 (January/February), p. 110.

Kent, Sarah. "Artificial Intelligence." *Time Out* (London), October 25, pp. 20–21.

Pitman, Joanna. "Shock of the Old." *The Times Magazine* (London), October 22, pp. 41–43.

Rondi, Joelle. "Bignan, Domaine de Kerguéhennec." *Art Press* (Paris), no. 261 (October), pp. 77–78.

Searle, Adrian. "Turner Prize." *G2*, supplement to *The Guardian* (London), October 24, pp. 12–13.

Urquhart, Conal. "Sci-fi Artist Finds His Work Is in New Orbit." *The Times* (London), November 28, p. 3.

Withers, Rachel. "Intelligence: New British Art 2000/The British Art Show 5." *Artforum* 39, no. 2 (October), p. 143.

1999

Benjamin, Marina. "Dalí Mixtures to Tickle the Jaded Palette." *Evening Standard* (London), May 6, Arts, pp. 34–35.

Brittain, David. "Glenn Brown." *Creative Camera* (London), no. 358 (June/July), pp. 1, 4.

Brown, Glenn. "Gerhard Richter, Anthony d'Offay Gallery." *Frieze*, no. 44 (January/February), p. 74.

Collings, Matthew. "Higher Beings Command." *Modern Painters* 12, no. 2 (Summer), pp. 58–64.

Darwent, Charles. "If You Want to Get Ahead, Get a Different Sort of Brain." *The Independent* (London), April 25.

Gellatly, Andrew. "It's a Curse, It's a Burden." *Frieze*, no. 45 (March/April), pp. 85–86.

Higgie, Jennifer. "Glenn Brown, Jerwood Gallery, London." *Frieze*, no. 47 (June/July/August), pp. 98–99.

Jones, Jonathan. "I Thought I Was in Ulm." *Untitled* (London), no. 19 (Autumn), p. 6.

———. *John Moores 21* exhibition review. *The Guardian* (London), September 28, p. 13.

———. "Pick of the Day." *The Guardian* (London), May 17.

Joni, Tom Ulford. "Glenn Brown." *TNT Magazine* (London), May.

Martin, Herbert. "Glenn Brown." *Time Out* (London), May 12.

Musgrave, David. "It's a Curse, It's a Burden." *Art Monthly* (London), no. 223 (February), pp. 36–38.

———. "We'll Drink Through It All: This Modern Age" (interview). *Untitled* (London), no. 19 (Summer), pp. 4–6.

Pagel, David. "Decorating Dreams: It's Interior Design." *Los Angeles Times*, July 2, p. 24.

Patrick, Keith. "Formal Dress, Alienation and Resignation at the Millennium Ball." *Contemporary Visual Arts* (London), no. 26 (Winter), pp. 46–51.

Sladen, Mark. "Glenn Brown: The Day the World Turned Auerbach." *Art/Text* (international edition), no. 64 (February/March/April), pp. 42–45.

1998

Dewan, Shaila. "What's So Great about Painting?" *Houston Press*, October 29, pp. 59–60.

1997

"Academy Show in Copycat Spat." *Evening Standard* (London), September 16, p. 10.

Fricke, Harald. "Das Fenster zur Welt ist ein Fernseher." *Taz* (Berlin), July 26.

Jennings, Rose, and Libby Anson. "Berlin; Venice." *Untitled* (London), no. 14 (Winter), pp. 16–17.

Kent, Sarah. "It's a Sensation! But Is It Art?" *Time Out* (London), September 10, pp. 4–5, 13.

Kyte, Matthew, and Darren Lees. "Glenn Brown in Conversation at His Studio." *The Slade Journal* (London) 1 (Summer), pp. 27–34.

Shone, Richard. "Lisbon: British Art 1960–Present." *Burlington Magazine* (London) 139, no. 1129 (April), pp. 283–85.

1996

Adams, Brooks. "Hodgkin's Subtexts." *Art in America* 84, no. 5 (May), pp. 39–40.

Dannatt, Adrian. "Brilliant." *Flash Art*, no. 186 (January/February), pp. 96–97.

Feaver, William. "Crooked Style." *The Observer Review* (London), November 17, p. 9.

Feldman, Melissa. "Twenty-one Days of Darkness." *Art Monthly* (London), no. 88 (April), pp. 39–40.

Findlay, Judy. "Twenty-one Days of Darkness." *Flash Art*, no. 189 (June/July), pp. 99, 30.

Graham-Dixon, Andrew. "On the Surface." *The Independent Tabloid* (London), November 19, pp. 4–5.

Hilton, Tim. "The Best Painting in Britain?" *The Independent on Sunday* (London), November 17, p. 30.

Searle, Adrian. "The Best of British Painting?" *The Guardian* (London), November 11, p. 10.

Wilson, Andrew. "The Vision Thing." *Art Monthly* (London), no. 202 (December), pp. 7–9.

1995

Archer, Michael. "Licensed to Paint." *Art Monthly* (London), no. 186 (May), pp. 8–10.

Auty, Giles. "Edge of the Black Hole." *The Spectator* (London), April 15, p. 42.

Brown, Glenn. "Glenn Brown on George Condo's *Clownmaker*: A Brush with Genius 20." *The Guardian* (London), November 14, p. 9.

———. "Glenn Brown on Willem de Kooning: Paintings at the Tate Gallery." *Frieze*, no. 22 (May), pp. 54–55.

Cafopoulos, Catherine. "Glenn Brown at Karsten Schubert." *Arti* (Athens) 27 (November/December), pp. 208–11.

Collings, Matthew. "Welcome to Our Repartee." *Modern Painters* 8, no. 4 (Winter), pp. 24–28.

Coomer, Martin. "From Here." *Time Out* (London), April 19, p. 46.

Cork, Richard. "Bright Young Things at Work and Play." *The Times* (London), September 26, p. 32.

Dorment, Richard. "Funny, but Too Peculiar." *The Daily Telegraph* (London), September 20, p. 16.

Gayford, Martin. "The Medium that Refused to Die." *The Daily Telegraph* (London), April 12, p. 19.

Hall, James. "Old Habits Die Hard." *The Guardian* (London), September 25, p. 6.

Hilton, Tim. "Fate, Hopelessness, Little Clarity." *The Independent on Sunday* (London), April 9, Sunday Review, p. 31.

Hooper, Mark. "Space 1995." *The Face* (London), no. 86 (November), pp. 84–85.

Hyman, James. "Presences and Spectral Traces." *Galleries Magazine* (London), July, p. 12.

Kent, Sarah. "Glenn Brown, Karsten Schubert." *Time Out* (London), July 26, p. 52.

———. "Pretty Vacant." *Time Out* (London), October 4, p. 51.

McEwen, John. "Young British Artists V." *The Sunday Telegraph* (London), October 1.

Morgan, Stuart. "Anglo-Saxon Attitudes." *Frieze*, no. 21 (March/April), p. 7.

Negrotti, Rosanna. "Spaced Out." *What's On Magazine* (London), October 4, pp. 12–13.

Norman, Geraldine. "Stampede Starts from Here." *The Independent* (London), April 3, p. 7.

Packer, William. "Only Artists with Attitude." *Financial Times* (London), September 9, p. 15.

Searle, Adrian. "Any Colour You Like as Long as It's a Joke." *The Independent* (London), April 4, p. 21.

———. "Art in the Wrong Place." *The Independent* (London), October 10, p. 9.

Wakefield, Neville. "Quite, Quite Brilliant." *Tate Magazine*, no. 8 (November), pp. 32–39.

Wilson, Andrew. "Breaking Content from Form: British Art Defining the 90s." *Art and Design* (London), no. 41, pp. 6–19.

1993
Beaumont, Peter. "Is Art Dead?" *The Observer* (London), February 14, p. 24.

Bennett, Oliver. "Exhibitionists!" *Evening Standard Magazine* (London), May.

Bonami, Francesco. "Vitamin P: The Sound of Painting." *Flash Art*, no. 173 (November/December), pp. 37–41.

"Dalí Dabbler." *The Times* (London), January 28, p. 20.

"Glenn Brown v. The Dalí Estate." *Untitled* (London), Spring.

Graham-Dixon, Andrew. "Radical Chic and the Shock of the New." *The Independent* (London), February 16, p. 12.

Harvey, William. "Copycat Crime." *City Limits* (London), February 4.

Hilton, Tim. "Familiar Signs of a Misspent Youth." *The Independent on Sunday* (London), February 7, p. 18.

Kent, Sarah. "Awards to the Wise." *Time Out* (London), February 3.

Morgan, Stuart. "Confessions of a Body Snatcher." *Frieze*, no. 12 (October), pp. 52–55.

Myers, Terry R. "Painting Invitational." *Flash Art*, no. 172 (October), p. 120.

Packer, William. "Crème de la Crème Goes Sour." *Financial Times* (London), February 2, p. 13.

Pitt, Alex. "Copyright Issues." *Art Monthly* (London), no. 166 (May), p. 17.

———. "Whose Art Is It Anyway." *The Observer* (London), May 9, p. 56.

Roberts, James. "Twin Peak: The Barclays Young Artists Award." *Frieze*, no. 9 (March/April), pp. 22–23.

Smith, Roberta. "Painting Invitational." *The New York Times*, July 2, p. 21.

Whitford, Frank. "Blind Man's Buff." *The Sunday Times* (London), February 31, pp. 10–11.

Wilson, Andrew. "London Winter Round-Up." *Art Monthly* (London), no. 163 (February), p. 20.

1992
Lorent, Claude. "Quand l'attitude devient art." *Art and Culture* (Paris) 7, no. 3 (November), pp. 7–11.

Palmer, Julie. "Surface Values: A Review." *Art and Design—Contemporary Painting* (London), Autumn.

1991
Collings, Matthew. "New Contemporaries at the ICA." *City Limits* (London), August 15, p. 18.

Dorment, Richard. "Painting with a Message." *The Daily Telegraph* (London), August 9, p. 13.

Jennings, Rose. "New Contemporaries, ICA." *City Limits* (London), January 11.

Kent, Sarah. "New Contemporaries, ICA." *Time Out* (London), August 7.

McEwen, John. "Artists A-Plenty." *The Sunday Telegraph* (London), December 8, p. 8.

Norrie, Jan. "BT New Contemporaries, ICA, Ikon Gallery." *Art Review* (London) 43 (April).

1989
Cork, Richard. "New Art Goes Under the Hammer." *Telegraph Weekend Magazine* (London), March 11.

Published on the occasion of the exhibition

Glenn Brown

15 October – 26 November 2009

Gagosian Gallery
6–24 Britannia Street
London WC1X 9JD
T. 020 7841 9960
www.gagosian.com

Editors: Robin Vousden and
Hannah Freedberg
Managing editor: Alison McDonald
Text editor: Nicole Heck
Photography coordinator: Ian Cooke

Gagosian Gallery coordinators: Verity
Brown, Emily Florido, Darlina Goldak,
Melissa Lazarov, Stefan Ratibor,
John Tiney, and Gary Waterston

Copy edited by Jennifer Knox White
Designed by Peter Willberg, London
Color separations by Echelon, Los Angeles
Printed in England by Beacon Press,
Uckfield

Glenn Brown would like to thank Larry
Gagosian and all at Gagosian Gallery, as
well as Milena Dragicevic, Rannva Kunoy,
Edgar Laguinia, Michael Raedecker,
and Mike Stubbs.

Distributed by Rizzoli International Publications
300 Park Avenue South
New York, NY 10010
www.rizzoliusa.com

ISBN 978-0-8478-3488-4

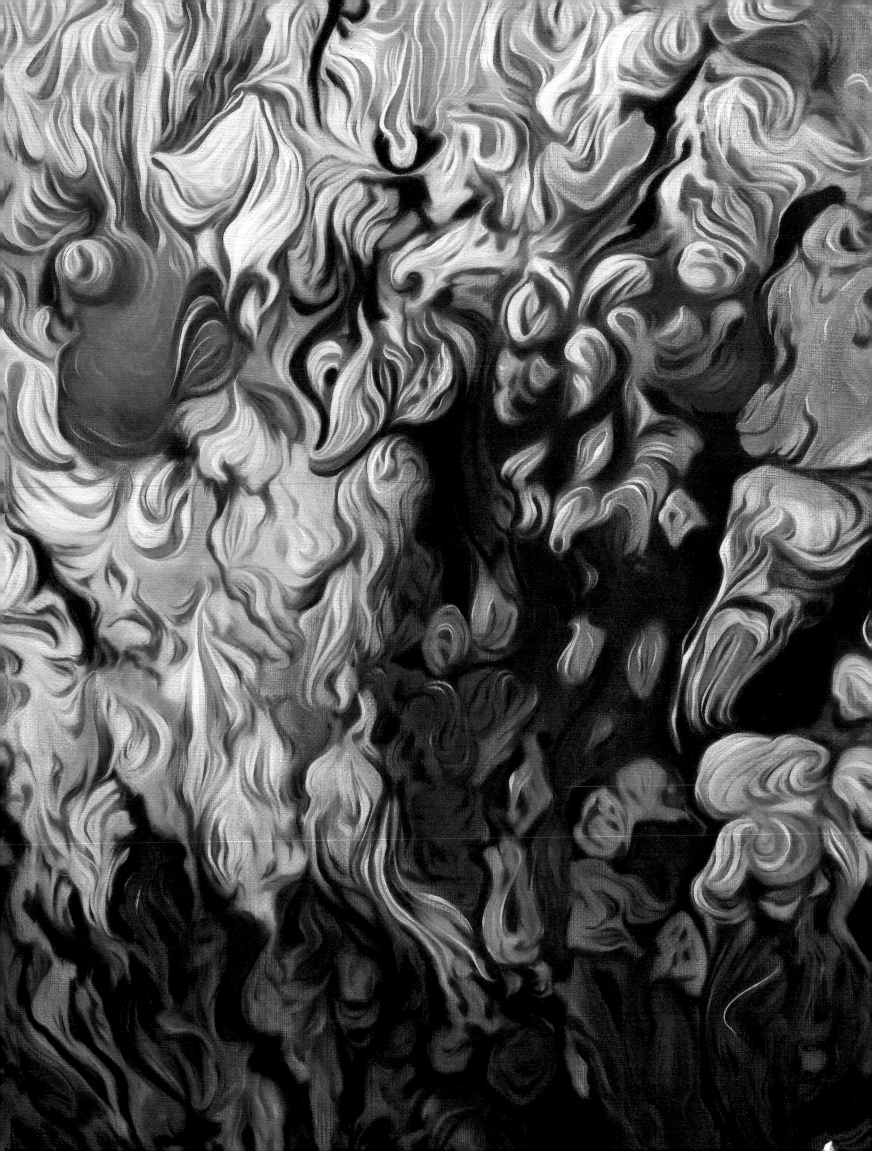